CONTENTS

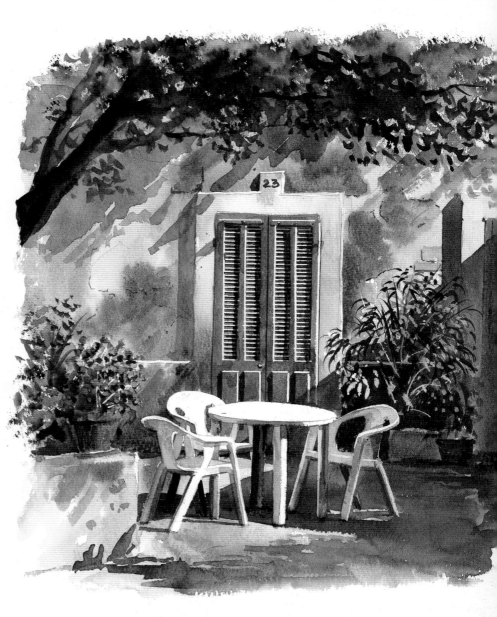

INTRODUCTION

I had an interesting conversation with a friend of mine, who is a very keen amateur artist, and he said he had all the books on how to paint, enough art materials to start his own art store, every gadget, gimmick and gismo known to mankind to help him become a better artist, but sit him in front of a sheet of white paper and he hadn't a clue what to paint! This is the artistic version of writer's block.

It got me thinking, what do I paint? And what makes me choose it? I can think of many reasons why I like a certain subject or what has prompted me to choose a particular view, so to me, what to paint is not the problem, in fact my problem is not having enough time to put down on paper all I want to paint.

Artists choose particular subjects for many different reasons; often it is a reminder of a past event, or perhaps memories of childhood or past holidays. There is one expression I have adopted as my motto in art: if I am looking for inspiration and considering a certain scene, I ask myself, is this a place where you would like to be? I must say, looking at some artists' work, I wonder why they would want to paint that! But it is a personal thing, if we all painted the same subjects in the same way, this would be a sad place to be. Some people respond to Picasso, and others to Constable.

You don't have to travel the world looking for the perfect location; often it is on your doorstep or right in front of your eyes. I am always looking for locations, it is a habit and a passion. When I am out and about, no matter what I am looking at, I am constantly thinking to myself whether or not that would make a nice painting. Always carry a camera with you, as taking too many photographs is better than missing out on something. You can always delete photographs, but never turn back time.

Going back to my friend, the amateur artist with the painter's block, I tried to imagine what I would have wanted to help me with my hobby when I began painting. In those days, when searching for subjects, I copied postcards, calendars and paintings by my favourite artists. This, then, is a book of my paintings that you can freely copy; I have even helped you by supplying the drawing for each project as a outline at the back of the book. With every painting is a list of the colours used and some suggestions of what brushes to use as well as a little background information about the painting and the inspiration behind it. There are useful tips on techniques and on how to paint the important aspects of the painting. This book will show you an easy way to transfer the images on to paper without the need to tear the outlines from the book, and there is advice on enlarging the outlines for the more adventurous. You are at liberty to change the composition, add to the paintings, or combine elements from one to another.

When you have finished your painting, you are free to do with it as you wish. You can frame it, give it away, exhibit it, or even, if it is that good, sell it. There is only one condition, and it is only polite – to write on the painting 'inspired by Terry Harrison'.

LANDSCAPES
IN WATERCOLOUR

Terry Harrison

SEARCH PRESS

First published in Great Britain 2011

Search Press Limited
Wellwood, North Farm Road,
Tunbridge Wells, Kent TN2 3DR

Text copyright © Terry Harrison 2011

Photographs by Paul Bricknell, Search Press Studios

Photographs and design copyright © Search Press Ltd 2011

ISBN: 978-1-84448-661-8

The Publishers and author can accept no responsibility for any consequences arising from the information, advice or instructions given in this publication.

Printed in China

Suppliers

If you have any difficulty obtaining any of the materials and equipment mentioned in this book, please visit the Search Press website: www.searchpress.com or the author's website: www.terryharrison.com

Acknowledgements

To prove that sometimes I do listen to what people say, thank you to my friend George Lee, I hope this book helps.
My thanks also go to Martin de la Bédoyère for listening to what I want in a book and to my editor, Sophie Kersey, for helping me put my thoughts into this book. A huge thank you to my new bride, Fiona Peart, for also listening to my pleas for help with all the typing, spell checking and endless cups of coffee.

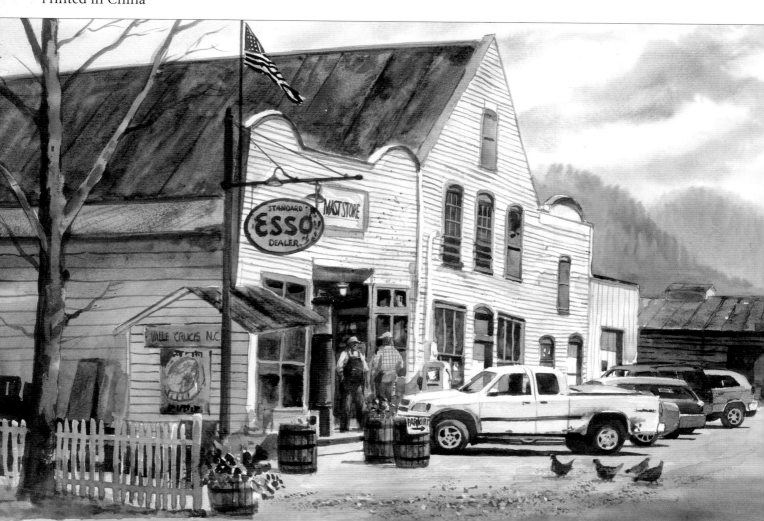

WHAT TO PAINT

LANDSCAPES
IN WATERCOLOUR

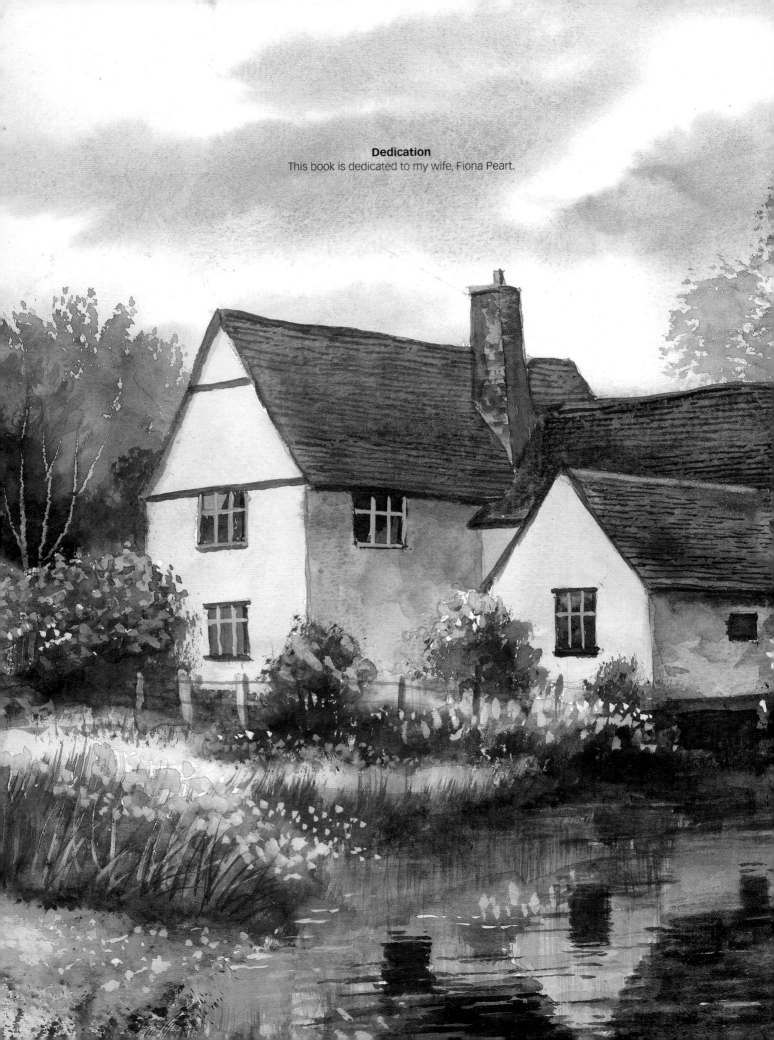

This project, *After the Rain*, appears on pages 26–27.

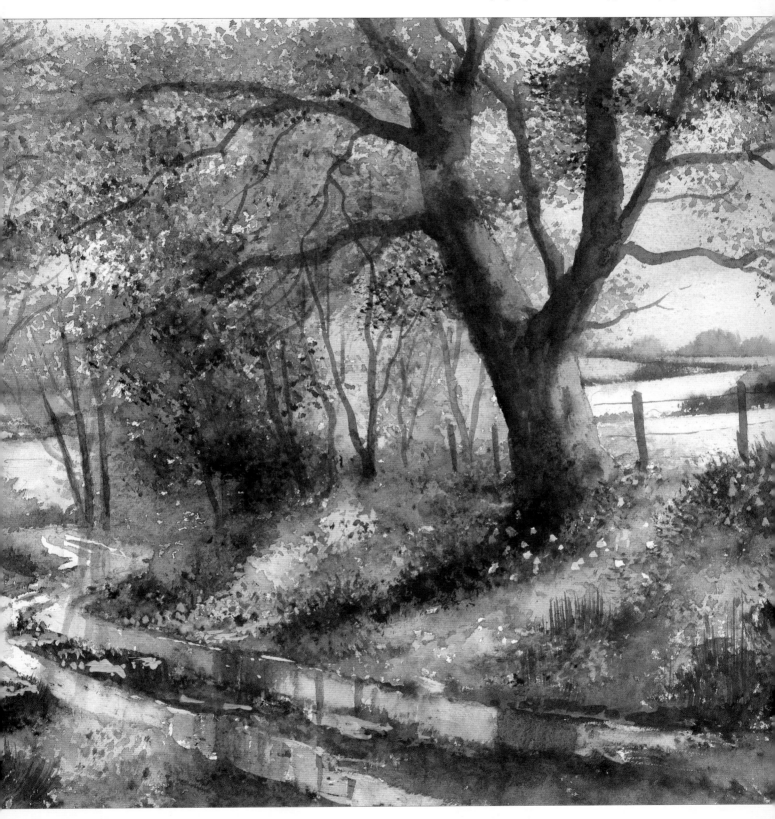

THE PAINTINGS

Some paintings are printed at right angles so that they all fit on to one page. Where this is the case, a miniature version is printed on the left-hand page with an arrow showing the right way up.

Poppies by the Track, page 16

Millstream Cottage, page 18

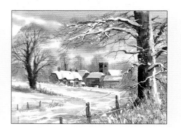
Winter's Day, page 20

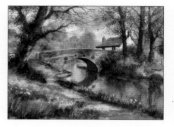
Towpath Cottage, page 22

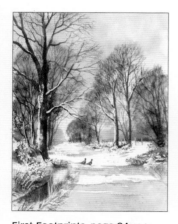
First Footprints, page 24

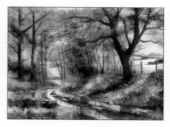
After the Rain, page 26

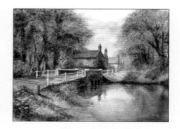
Sleepy Hollow, page 28

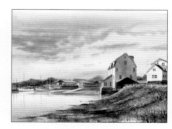
Tide Mill, page 30

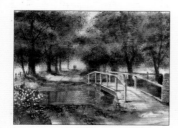
A Walk Along the Lane, page 32

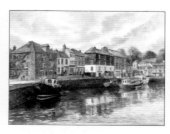
Cornish Harbour, page 34

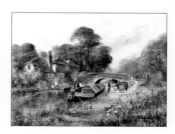
The Mooring, page 36

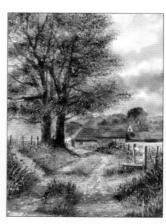
The Road to the Farm, page 38

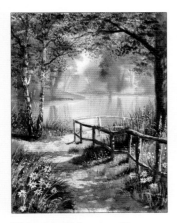

Waterside Walk, page 40

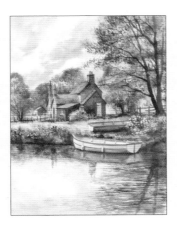

The Ferryman's Cottage, page 42

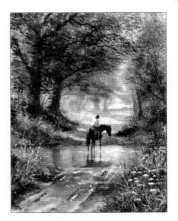

Cooling Off, page 44

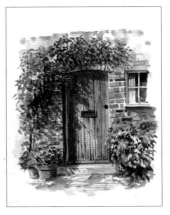

The Green Door, page 46

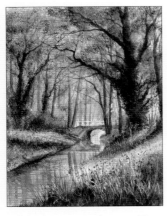

Off the Beaten Track, page 48

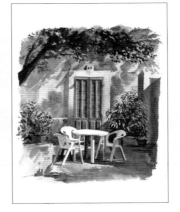

Courtyard Shade, page 50

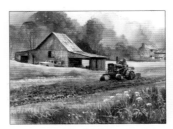

Hard Day's Work, page 52

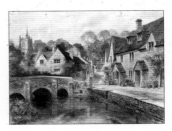

Castle Combe, page 54

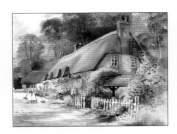

The Village Gossips, page 56

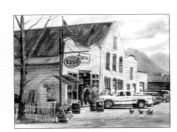

Chatting on the Porch, page 58

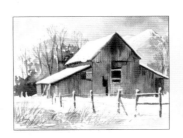

Another Winter, page 60

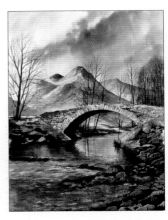

The Mountain Stream, page 62

TRANSFERRING THE IMAGE

You do not need to remove the outlines from the book to transfer them on to watercolour paper if you follow the methods shown below. You can also photocopy or scan the outlines, enlarge them to the size you want and then transfer them as shown.

Using tracedown paper

This is an easily available paper for transferring images, sometimes known as graphite paper, and is similar to the carbon paper that was used in the days of typewriters.

1. Slip your sheet of watercolour paper directly under the outline you want to use.

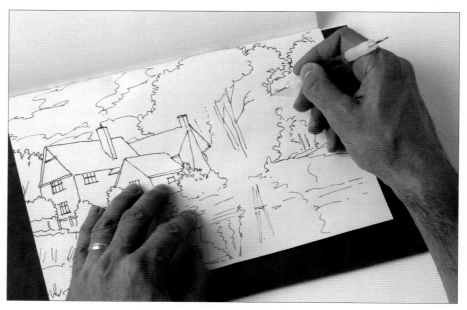

2. Slip a sheet of tracedown paper between the outline and the watercolour paper. Go over the lines using a burnisher.

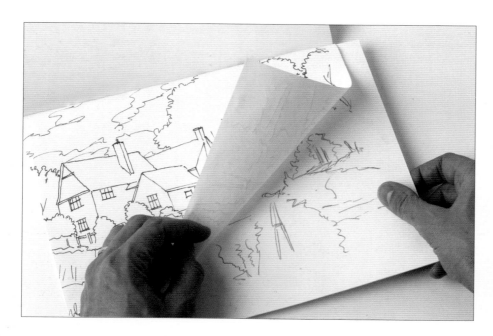

3. Remove the tracedown paper and lift up the outline to reveal the image transferred on to your watercolour paper, ready for you to begin painting.

Using pencil

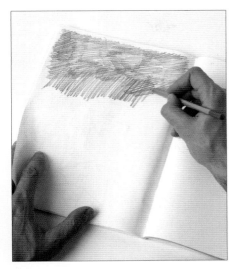

1. Turn to the back of the outline you want to transfer. Scribble over the back with a soft pencil.

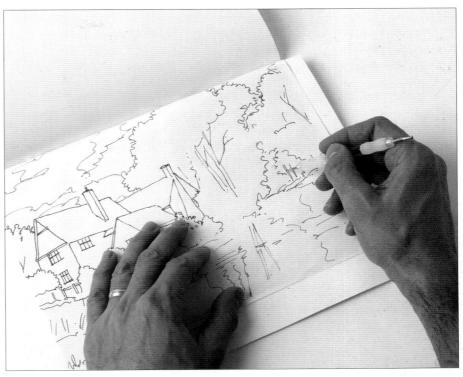

2. Turn the page so that you are looking at the image you want to transfer. Place your watercolour paper underneath the page. Go over the lines with a burnisher.

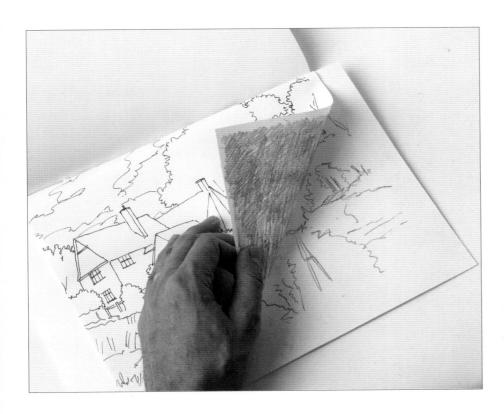

3. Lift the page to reveal the image transferred on to your watercolour paper. When you remove the watercolour paper, make sure you put a piece of scrap paper in between this outline and the next to avoid graphite from the back of the page transferring on to the next outline.

HOW TO USE THIS BOOK

You can reproduce the paintings in this book pretty much as I have painted them, using the outlines and the advice with each project. However, you may want to branch out and adapt the paintings to your own taste. You could take one element from an outline and place it in a different background, or use exactly the same outline but paint the scene in a different season, or in a different colour scheme, perhaps with different flowers in the landscape.

You may want to work on a larger scale, in which case you can easily photocopy or scan an outline and then enlarge it to the size you prefer.

Opposite
This painting uses the outline from *The Mountain Stream* on pages 62–63, but shows the scene in deepest winter. For advice on painting snow, see *Winter's Day* (pages 20–21), *First Footprints* (pages 24–25) and *Another Winter* (pages 60–61).

This tranquil scene features the boat from *The Ferryman's Cottage*, shown on pages 42–43, but placed in the woodland background from *After the Rain* on pages 26–27. The flooded path from *After the Rain* has been transformed here into a stream. People find it difficult to draw boats, so you might want to reuse this one in other scenes of your own, perhaps showing it on a lake or a beach.

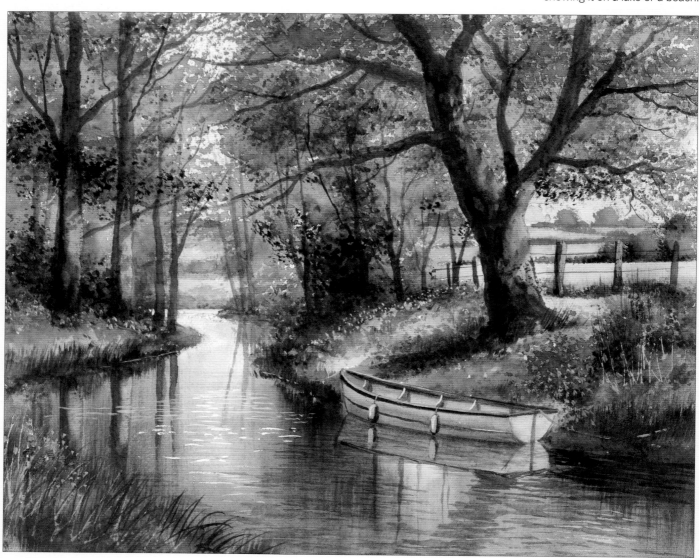

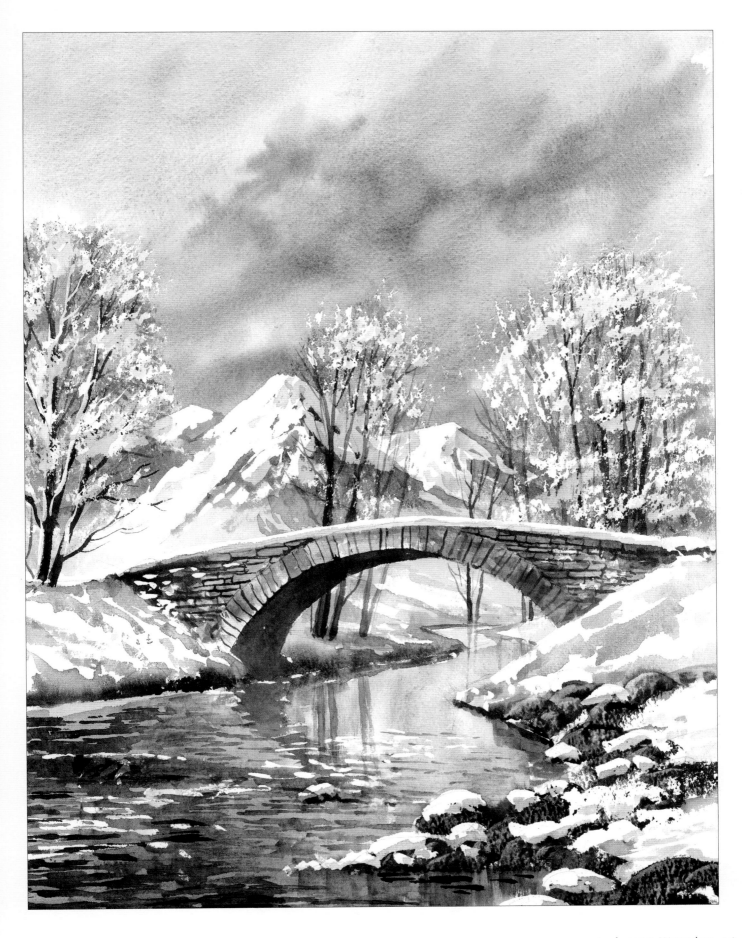

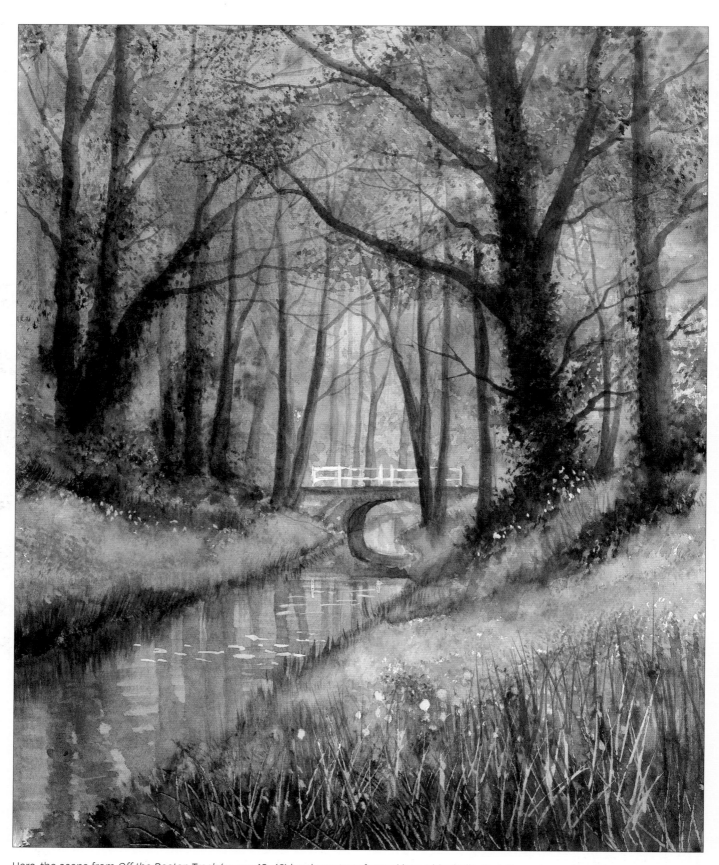

Here, the scene from *Off the Beaten Track* (pages 48–49) has been transformed into a bluebell wood. The colour scheme here features much bluer greens, fitting the springtime theme. The bluebells were painted with cobalt blue and permanent rose.

BRUSHES AND COLOURS

I have my own range of brushes that I have had specially made to help you achieve plenty of useful painting effects with the minimum fuss. These are mentioned in some of the projects, but you can of course use brushes from other ranges as long as they have the qualities needed, which are discussed below.

The golden leaf brush is useful for applying washes, for instance for skies, as it holds lots of water and paint. You could use a large wash brush instead. It is also used in many of the projects for stippling foliage on to trees. For this application, if you do not have the golden leaf brush, you should choose a large bristle brush.

The foliage brush is also used for stippling on foliage and for creating other textured effects. You could use a bristle brush of a similar size instead.

The wizard brush is made from natural hair, twenty per cent of which is longer than the rest, which helps with many textured effects. I have used it for woodgrain, reflections and a thatched roof. You could use a 10mm (³/₈in) one-stroke brush instead.

Most ranges include flat brushes. I have used my 13mm (½in) flat for ripples, with a side to side motion of the flat end, and for reflections, dragging the paint down into the water.

My half-rigger is like an ordinary rigger brush but shorter, making it easier to control. I have used it for fine detail throughout the projects.

My large, medium and small detail brushes are used for much of my painting. They all go to a fine point so are good for detail of varying sizes, and the large detail brush also holds plenty of liquid, so is good for applying washes. Alternatives would be no. 12, no. 8 and no. 4 round brushes.

PALETTE OF COLOURS

- Cadmium yellow
- Raw sienna
- Burnt sienna
- Burnt umber
- Cadmium red
- Permanent rose
- Cobalt blue
- Ultramarine
- Sunlit green
- Country olive
- Midnight green
- Shadow
- White gouache

I have used a limited palette of colours for the paintings in this book, shown left. For some of the paintings I have limited the number of colours even further, but most of them use all the colours shown.

As well as brushes, I have some paint colours manufactured specially to suit my purposes. I like to use ready-made greens, since I find that if I make up greens, I can end up mixing too many colours, and the results can be muddy instead of clear and vibrant. My greens are called midnight green, country olive and sunlit green, but if you do not have these, you could instead use Hooker's green, olive green and green gold. I also have a shadow colour which I have used in many of the projects. If you do not have this, you could mix French ultramarine, burnt sienna and permanent rose.

POPPIES BY THE TRACK

This old barn provides the focal point for the painting, and the farm track leads the eye towards the barn but also takes you past the tree and makes you wonder what is beyond this idyllic rural scene.

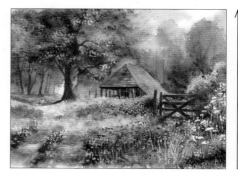

The trees at the back of the barn were painted using my golden leaf brush, wet into wet, meaning that wet paint was painted on to a wet background, creating soft effects. Then when this was dry, the tree trunks were added using the half-rigger. To make the barn stand out more and the roof look sunlit, the background trees next to the roof were painted quite dark. A lot of masking fluid was used to create the detail of the flower heads in the foreground. The contrast between the dark, shaded foreground and the light, warm colours of the centre ground gives the painting a real sense of summer.

Before painting, the areas to be masked are the poppies, flower heads, grasses, tree trunk, fence posts and gate.

PALETTE OF COLOURS

- Cadmium yellow
- Raw sienna
- Burnt sienna
- Burnt umber
- Cadmium red
- Permanent rose
- Cobalt blue
- Ultramarine
- Sunlit green
- Country olive
- Midnight green
- Shadow
- White gouache

The light sunlit leaves on the large tree were first masked with masking fluid using an old sponge. The tree trunk was masked at the same time, then painted over using the golden leaf brush and dark greens. The dark parts of the tree trunk and branches were painted using the medium detail brush. Once this was dry, the masking fluid was removed to reveal the light foliage and the sunlight on the trunk. A pale wash of light green was then washed over the highlights.

The gate and fence post were masked first then painted over. When the paint was dry, the masking fluid was removed to reveal the white of the paper. A pale mix of raw sienna and country olive was washed over the woodwork, and when dry, the darker shades were painted on the left-hand side of the posts. Be careful to leave the light on the top of the gate rails.

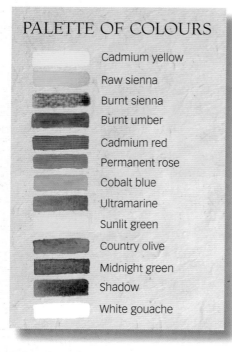

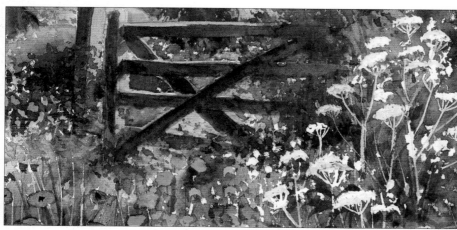

A ruling pen was used with masking fluid to mask the grasses and the cow parsley stems. Additional detail was added to the finished flowers using the half-rigger and white gouache.

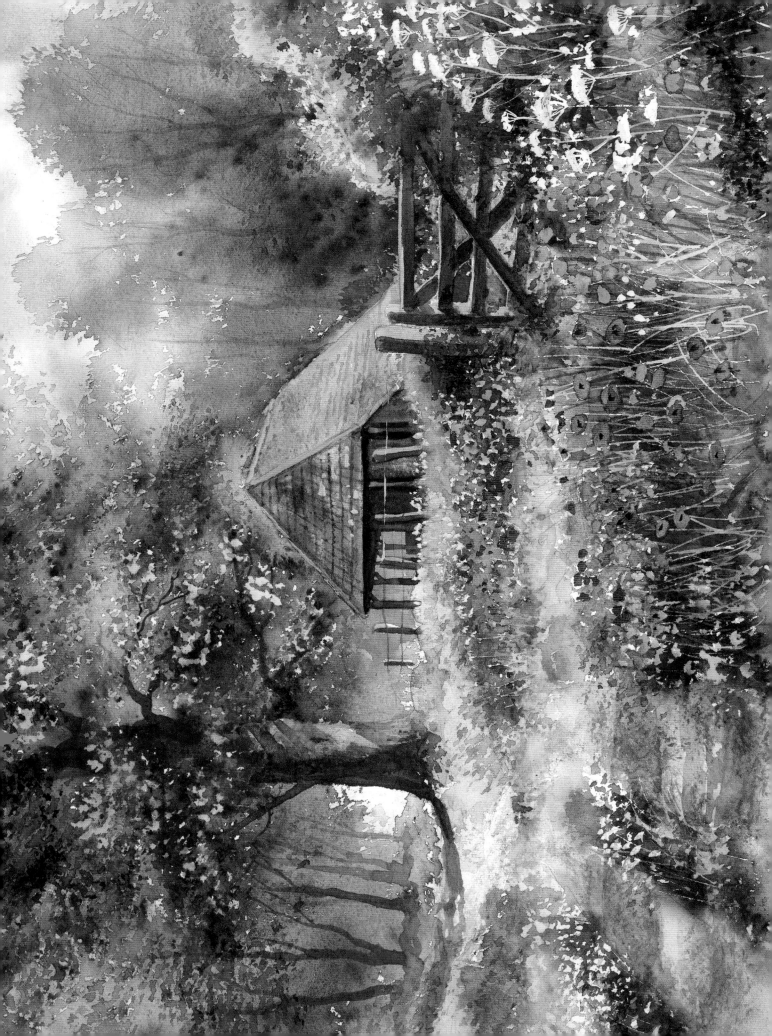

MILLSTREAM COTTAGE

You might recognise this cottage from another painting, not mine, but John Constable's *The Hay Wain*. This is Willy Lott's cottage next to Flatford Mill in Suffolk. Painting this scene gave me a big thrill; to actually stand in the same place and paint the same view as my artistic hero, John Constable, was a spiritual experience. The cottage is quite strong and bold in contrast to the soft, hazy trees downstream in the distance. When choosing this view, I was careful to include the reflections of the building in the water. Masking fluid was used for the flower heads, but for the yellow flowers at the water's edge I used neat cadmium yellow and dotted the flowers over the dark background.

PALETTE OF COLOURS

- Cadmium yellow
- Raw sienna
- Burnt sienna
- Burnt umber
- Cadmium red
- Permanent rose
- Cobalt blue
- Ultramarine
- Sunlit green
- Country olive
- Midnight green
- Shadow
- White gouache

The cottage is painted an off-white colour. I used raw sienna with a touch of permanent rose and plenty of water. For the walls in shade I used some shadow added to the first mix. The roof was painted wet into wet, starting with burnt sienna as a base wash, then dropping in raw sienna and shadow. Green was then added in places to make it appear more rustic and covered with moss. When this was dry, the roof tiles were painted using the half-rigger.

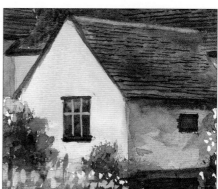

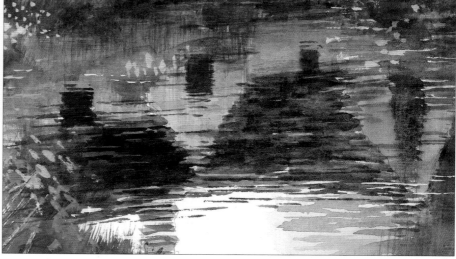

The reflections in the water were painted using the 13mm (½in) flat, with short horizontal brush strokes. Some of the lighter ripples were lifted out with an almost dry brush. The white ripples were created with masking fluid.

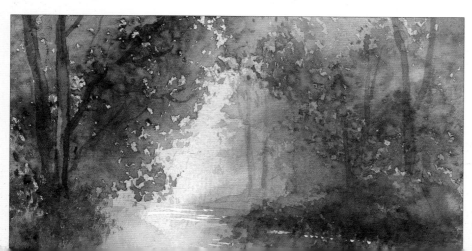

The misty trees on the right were painted wet into wet, using pale cobalt blue, midnight green and cadmium yellow, then when these were dry, the main tree to their left was painted over the distant trees using the golden leaf brush. This is called wet on dry. The half-rigger brush was used for the tree trunks and branches.

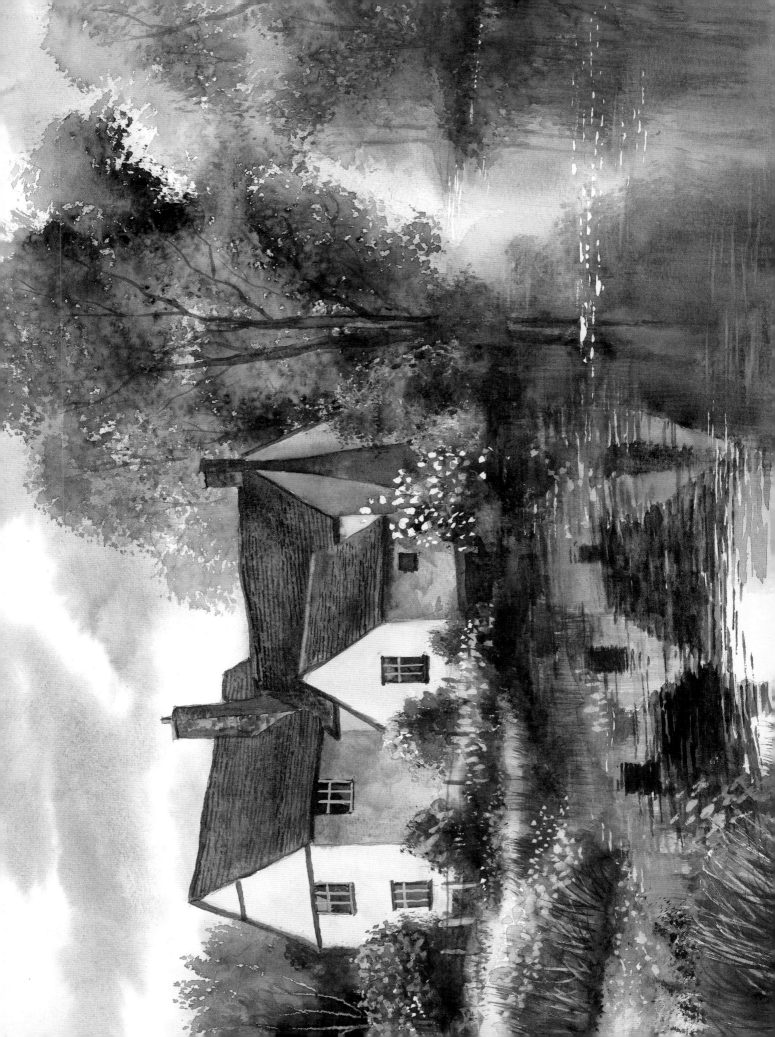

WINTER'S DAY

This little cluster of snow-clad buildings is part of a small hamlet near the village of Dogmersfield in North Hampshire. The original reference was a photograph taken in the summer, but at the time of doing the painting, I was looking for a snow scene I could use as a Christmas card. What I wanted was an image of the iconic perfect village, thatched cottages and a church in the snow, so I adapted and changed the view to suit. It is called artistic license!

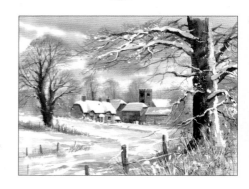

PALETTE OF COLOURS

- Cadmium yellow
- Raw sienna
- Burnt sienna
- Burnt umber
- Cadmium red
- Permanent rose
- Cobalt blue
- Ultramarine
- Sunlit green
- Country olive
- Midnight green
- Shadow
- White gouache

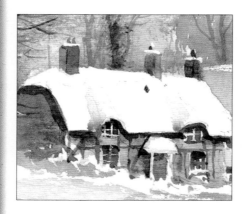

I converted the old farmhouse into a thatched cottage and added the red door to make it more homely and welcoming. To make the snow-covered roofs stand out, I added some dark trees at the back of the buildings using the foliage brush and the half-rigger. This gives the contrast needed to make the snow on the roofs more defined.

A lot of masking fluid was used for the trees and the grasses. Care was taken to place the masking fluid on the top of the branches, as when the fluid is removed, this represents the snow.

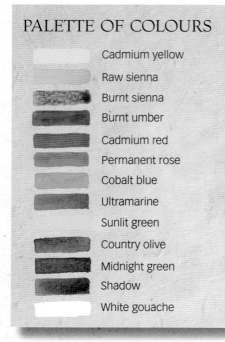

A ruling pen and a small brush were used to apply masking fluid for the grasses and fence wire. Opaque white gouache can be used to tidy up and add fine detail when the rest of the painting is finished.

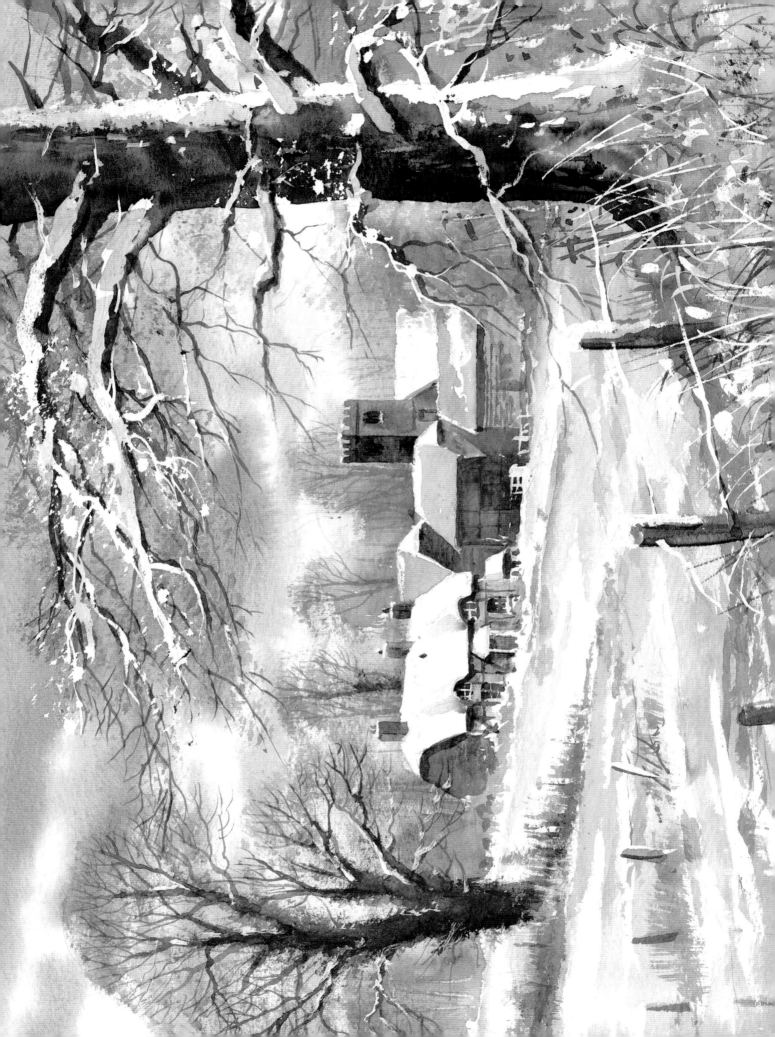

TOWPATH COTTAGE

I love painting canal scenes; they provide an endless supply of fabulous, tranquil painting reference. Not every canal is worth painting, I know that, but this particular canal that snakes its way through the open countryside of Hampshire is a gem. All waterways have easy access and are open to the public with an uninterrupted public footpath (the towpath) running along the side of the canal. My favourite subjects are bridges, since they are a focal point and a landmark linking one side of the painting with the other. This particular bridge is also pictured in the painting on page 36, but I have painted it from the other side and changed the building slightly to make it simpler so as not to take attention away from the old bridge.

PALETTE OF COLOURS

- Cadmium yellow
- Raw sienna
- Burnt sienna
- Burnt umber
- Cadmium red
- Permanent rose
- Cobalt blue
- Ultramarine
- Sunlit green
- Country olive
- Midnight green
- Shadow
- White gouache

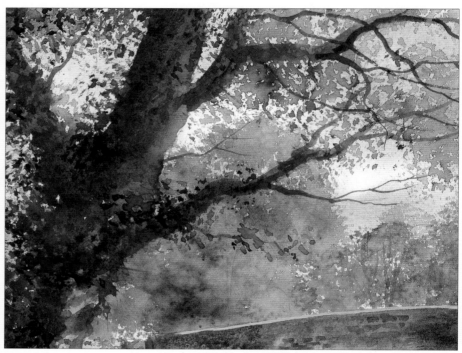

The ivy-clad tree on the left bank leans into the painting and the lower branches reach out over the water to form an arch with the trees opposite. This helps to frame the focal point – the bridge. The foliage was stippled using the golden leaf brush.

The background trees were painted bluer and paler to create the effect of distance. The same colours are reflected into the water. The tree trunks and branches were added with the half-rigger once the foliage had dried.

The bridge could look like a barrier across the painting, but the eye is drawn through the arch and into the distance. The colour used for the brickwork is burnt sienna with raw sienna and some shadow is used to tone the colours down.

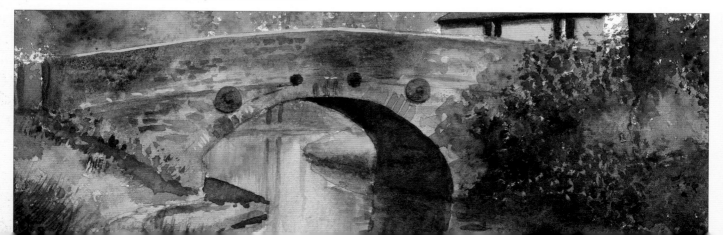

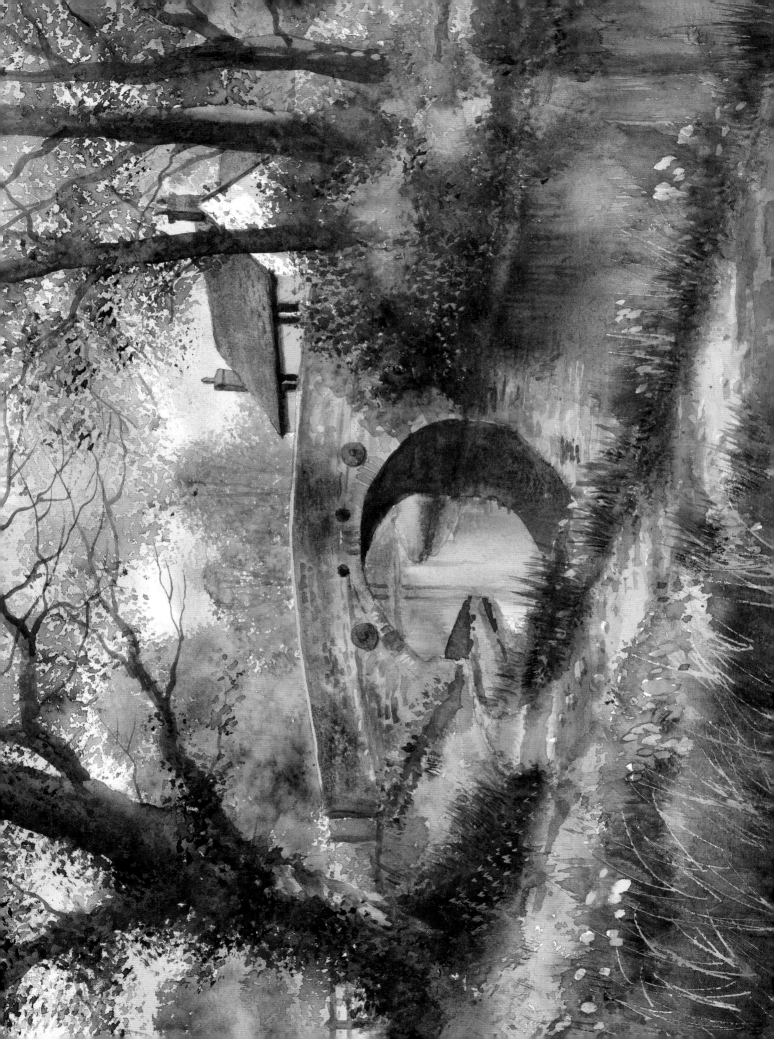

FIRST FOOTPRINTS

You would think a snow scene would be an easy thing to paint on a white sheet of paper, but it is not as simple as it first seems. The key is what you don't paint. This painting has very little white paper left showing, and the white that is left helps to draw your attention to the focal point and the subject of this painting: the pheasants crossing the lane. By placing the birds in the white space, you make them stand out really well. Masking fluid is ideal for preserving the white of the snow, especially where it clings to the branches and tree trunks. I am not a big fan of bleak, cold winter scenes, so in this painting I have used some warm colours that contrast with the cool, crisp blues of the foreground.

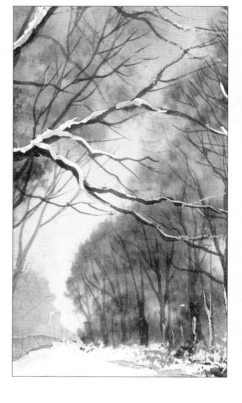

PALETTE OF COLOURS

- Cadmium yellow
- Raw sienna
- Burnt sienna
- Burnt umber
- Cadmium red
- Permanent rose
- Cobalt blue
- Ultramarine
- Midnight green
- Shadow
- White gouache

Raw sienna provided the warm glow in the sky at the horizon, and then ultramarine was added towards the top of the sky. The tree shapes were painted over the still-wet sky using burnt sienna and shadow. This technique creates a softer wet into wet finish. When this was dry, the branches and tree trunks were painted in using the half-rigger and a stronger, darker mix of the same two colours.

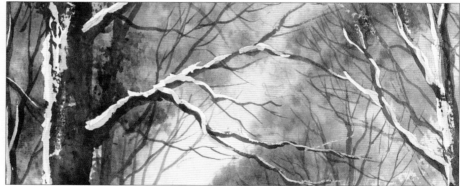

The masking fluid, when removed, becomes the snow lying on the branches. Care must be taken when painting the branches that the darks are painted on the underside of the masking fluid. Cobalt blue can soften and shade these stark white sections at the same time.

The shadows across the lane were created using cobalt blue in the distance with a touch of my shadow colour added in the foreground. It is important to paint these shadows horizontally across the lane and not on a slope.

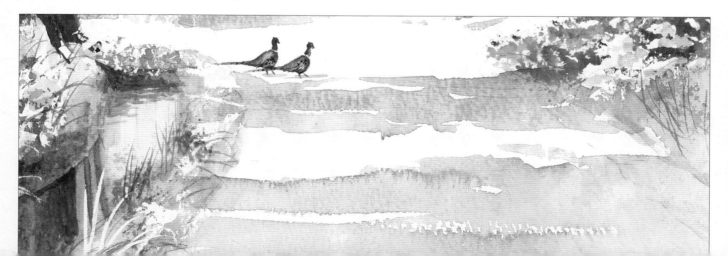

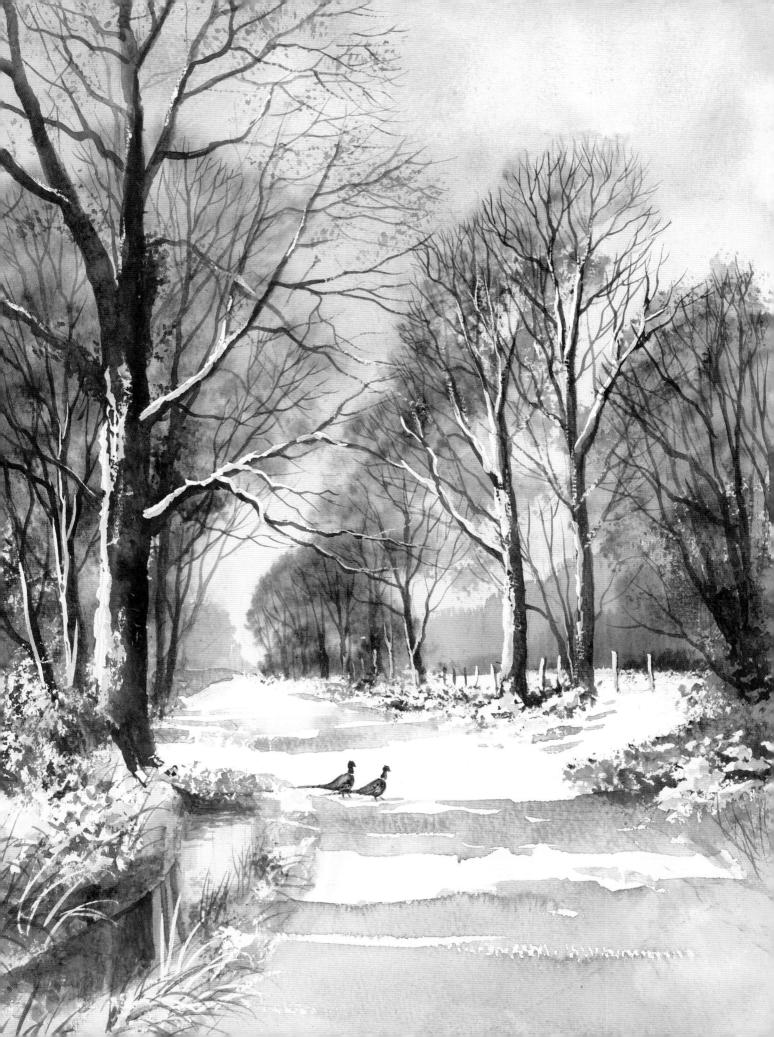

AFTER THE RAIN

I love painting this type of scene: a winding country lane enclosed on either side by shady trees, with small glimpses of countryside visible through the foliage between the trees. Instead of choosing the safe option of a sandy farm track, I have chosen to have plenty of puddles and water underfoot. This makes it more interesting because of all the reflections and the light coming off the water. It is late summer with a hint of some autumn tints. If all the trees and foliage were painted using only greens, the scene might have looked flat and lacked interest, but by introducing other colours such as yellows and burnt sienna, I have ensured that there is plenty of lively variety.

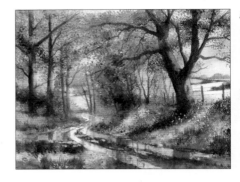

PALETTE OF COLOURS

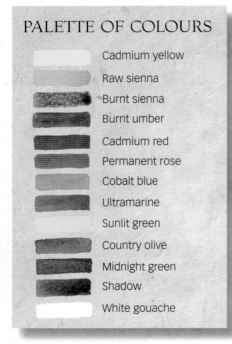

Cadmium yellow

Raw sienna

Burnt sienna

Burnt umber

Cadmium red

Permanent rose

Cobalt blue

Ultramarine

Sunlit green

Country olive

Midnight green

Shadow

White gouache

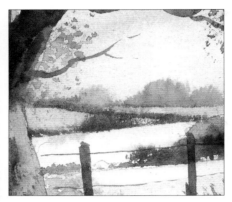

Glimpses of distant countryside can open up a painting. The effect of distance is created by keeping the trees furthest away a pale blue-green, then as the trees come closer, they are painted a darker green with less blue.

The sunlight filters through the trees and falls across the bank and on to the track. This looks brighter if the trees on either side are much darker.

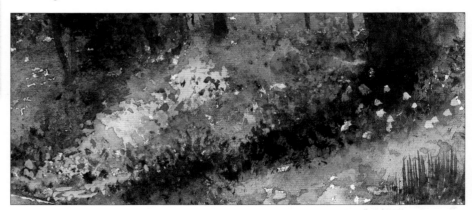

I believe water appears wetter if you can see some reflections in the water, such as tree trunks or the sky.

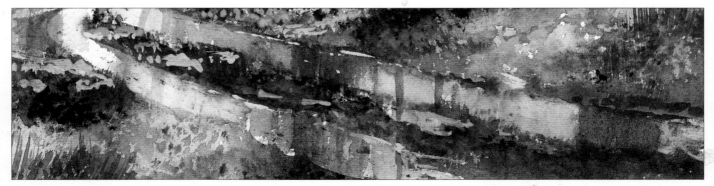

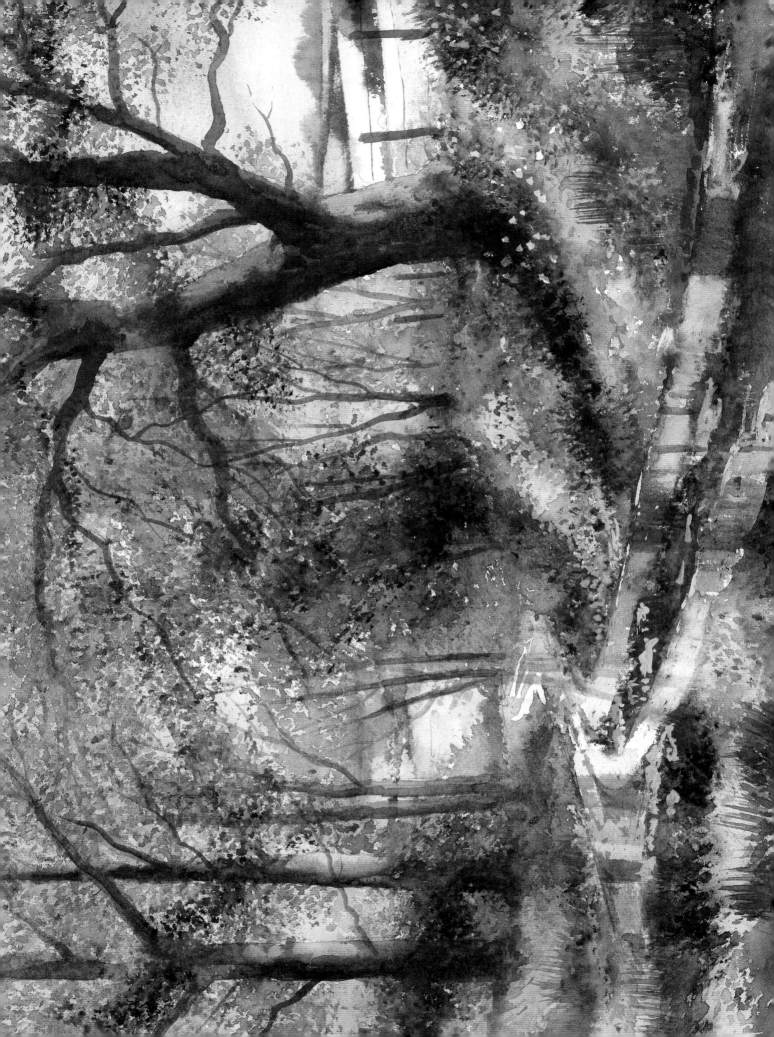

SLEEPY HOLLOW

This peaceful scene gives you the opportunity to paint buildings, foliage and water. It is a painting with plenty of depth; you really feel you can walk right the way up the road and into the painting.

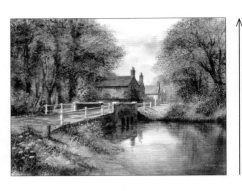

PALETTE OF COLOURS

- Cadmium yellow
- Raw sienna
- Burnt sienna
- Burnt umber
- Cadmium red
- Permanent rose
- Cobalt blue
- Ultramarine
- Sunlit green
- Country olive
- Midnight green
- Shadow
- White gouache

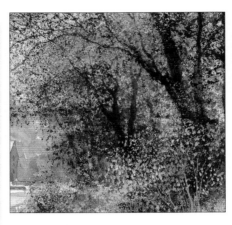

The effect of foliage is built up in layers by stippling with a foliage brush or bristle brush. I use ready-made greens but vary them by mixing. This avoids using too many colours and ending up with muddy greens.

The effect of distance is created both by the linear perspective of the buildings, with the lines sloping down towards and vanishing point, and by the bluer colours and paler tones used to paint distant buildings and trees.

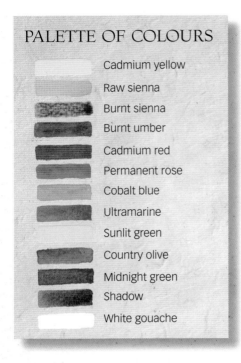

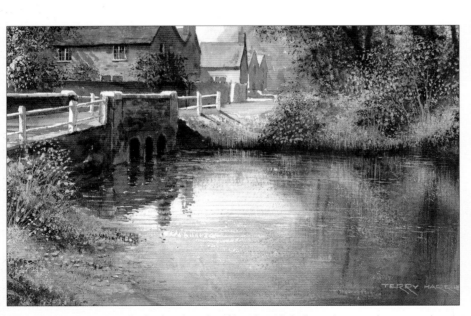

The reflections were created using the wizard brush and similar colours to the scene above, then this was allowed to dry. Finally, ripples were added using white gouache mixed with a little cobalt blue and the 13mm (½in) flat brush.

Masking out so many flowers with masking fluid could have been fussy, so these were applied with a fine brush and opaque white gouache mixed with watercolour.

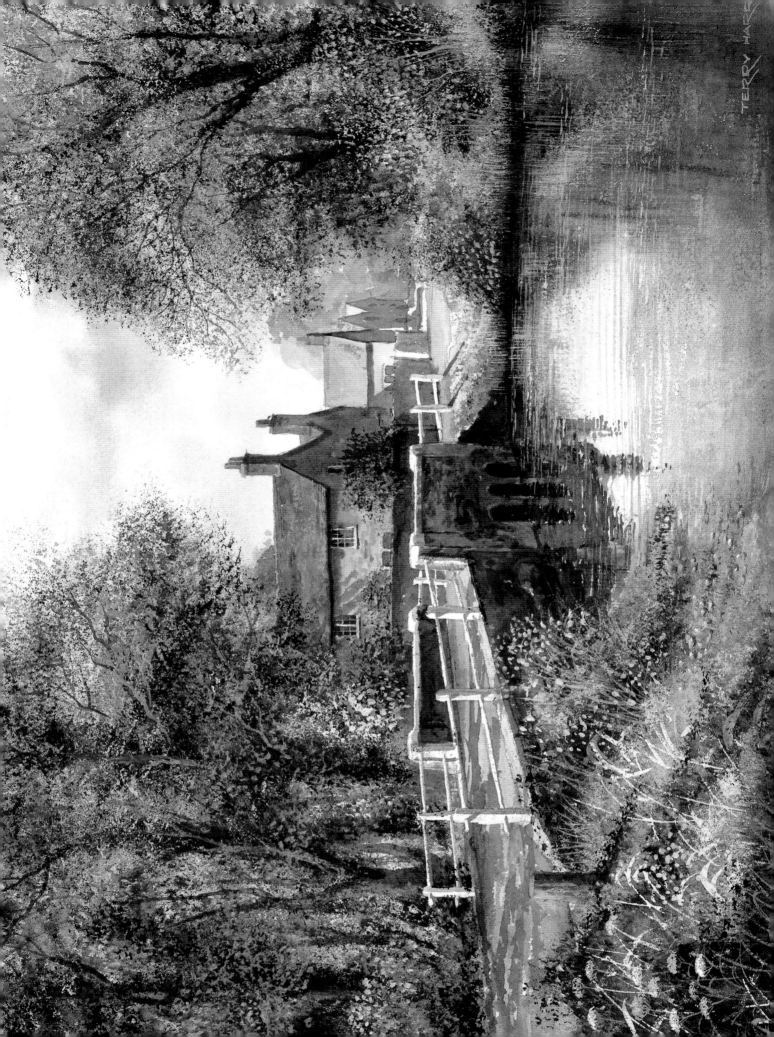

TIDE MILL

This Tide Mill is in Woodbridge in Suffolk, and it is a much-painted landmark in East Anglia. The usual view of the mill is taken from the boatyard on the quay at the front of the mill, but with some effort and muddy feet, I managed to capture this view at low tide from the other side. I wanted to include the boatyard and a big, dramatic sky.

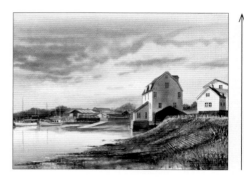

OUTLINE **8**

PALETTE OF COLOURS

Raw sienna

Burnt sienna

Burnt umber

Cobalt blue

Country olive

Shadow

White gouache

A limited palette of colours gives this painting simplicity and impact, with the sky colours of shadow, burnt umber and cobalt blue and raw sienna being reflected below in the water, land and buildings, with the addition of a little warm country olive in the foreground.

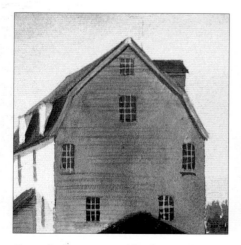

The soft effects created by the wet into wet techniques used for the sky, distance and water contrast with the sharper detail of the buildings, painted wet on dry. The dry brush technique is used to create the textures of the foreground – the brush is loaded with paint and then the excess liquid is removed by blotting on kitchen paper. The dry brush is then dragged on its side over the surface of the rough paper, leaving textured effects.

The reflections are kept simple in this painting, to avoid cluttering a peaceful scene, with just a few vertical strokes for mast reflections breaking up a composition full of long, horizontal lines.

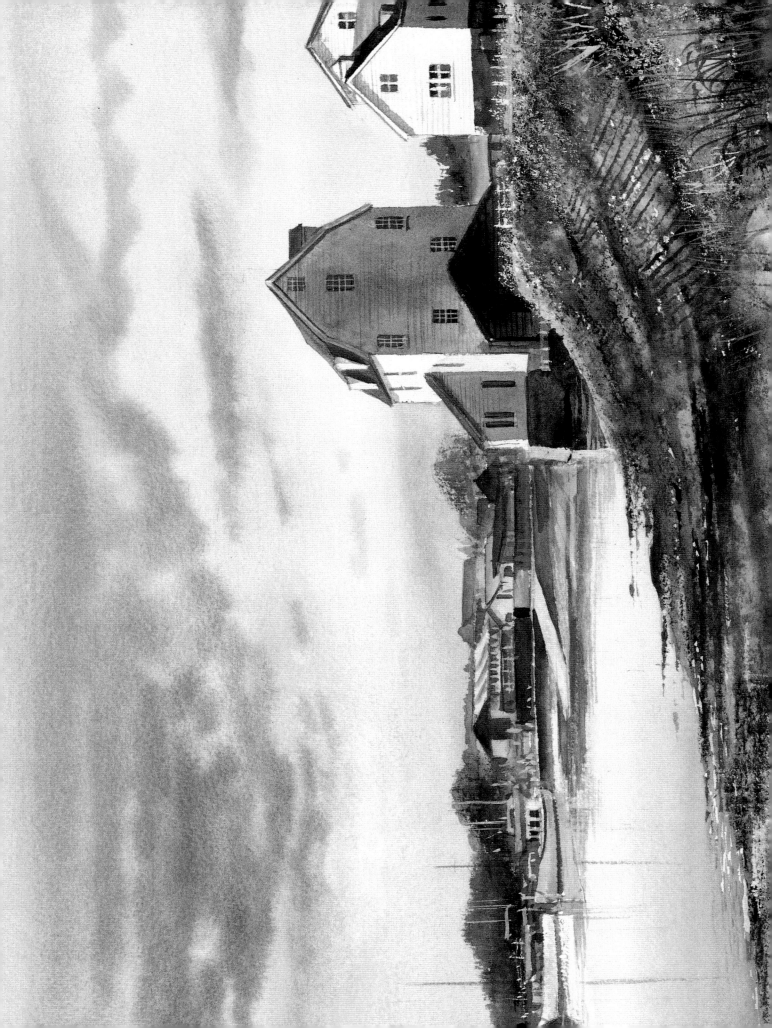

A WALK ALONG THE LANE

The locals know this little wooden bridge by a ford as the Donkey Bridge – I have no idea why, but I like the sound of it. Bridges make such good subjects. Without it, this shady lane would be cut in half by the stream, but the bridge leads you safely to the other side and down the lane into the painting. The roadside trees are quite dark as they overhang the track; stippling with the golden leaf brush captured their foliage. The misty meadows are just visible between the trees. To add some human interest, I have added a couple out for a stroll.

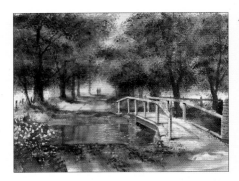

PALETTE OF COLOURS

- Cadmium yellow
- Raw sienna
- Burnt sienna
- Burnt umber
- Cadmium red
- Permanent rose
- Cobalt blue
- Ultramarine
- Sunlit green
- Country olive
- Midnight green
- Shadow
- White gouache

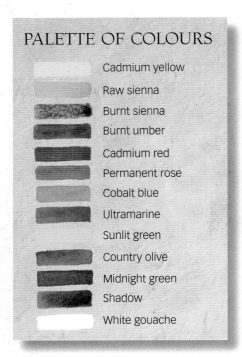

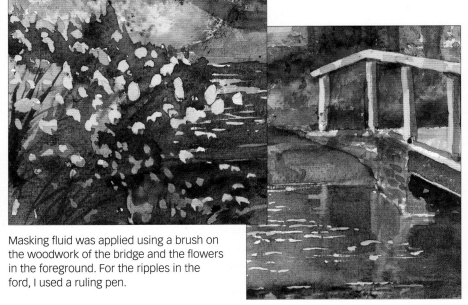

Masking fluid was applied using a brush on the woodwork of the bridge and the flowers in the foreground. For the ripples in the ford, I used a ruling pen.

The strong sunlight between the trees and the shadows crossing the road help to break up the eyes' journey down the road and into the painting. The feeling of depth is created by the trees becoming lighter in tone the further away they are.

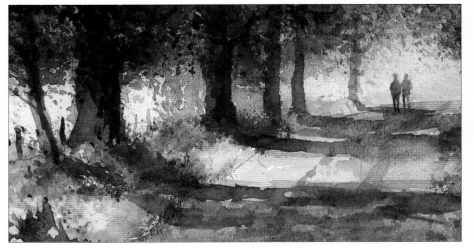

Placing something living in a painting adds interest or a focal point; alternative subjects could be some ducks in the water, a horse in the fields or perhaps a man walking a dog.
I have positioned the couple a long way down the lane, as if they were closer, I think they would dominate the painting too much.

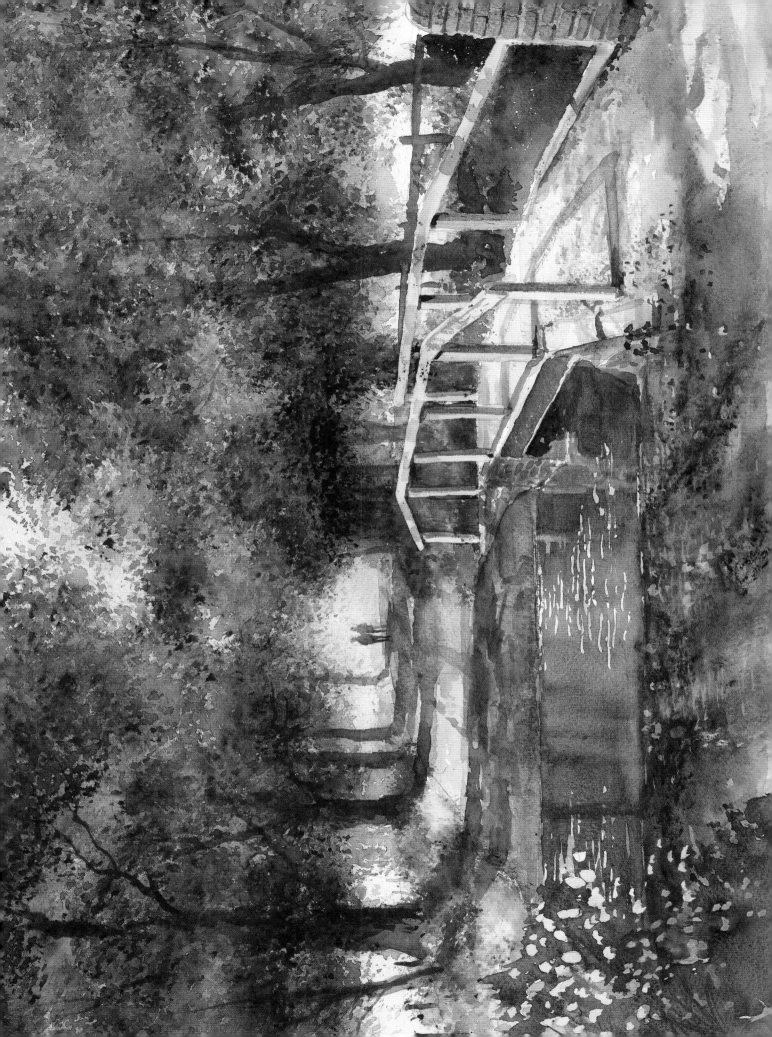

CORNISH HARBOUR

When choosing a scene to paint, it is not necessary to have an idyllic subject – we paint things that remind us of happy memories or a favourite holiday destination. Padstow in Cornwall is a good example: it is not the prettiest of harbours, but it is much loved by visitors. In the summer, the quay is packed with holidaymakers and day-trippers. Padstow is a fabulous place to visit, with plenty of gift shops, galleries and its famous fish restaurants. The harbour is easily recognisable, but has no real focal point. For this painting, I have chosen a panoramic view of the quay, to include the old Customs House on the right, but not far enough round to feature my favourite fish and chip shop.

PALETTE OF COLOURS

- Cadmium yellow
- Raw sienna
- Burnt sienna
- Burnt umber
- Cadmium red
- Permanent rose
- Cobalt blue
- Ultramarine
- Sunlit green
- Country olive
- Midnight green
- Shadow
- White gouache

The windows were first painted using a dark mix of ultramarine and burnt umber, and then when this was dry, the window frames were added using the half-rigger and white gouache.

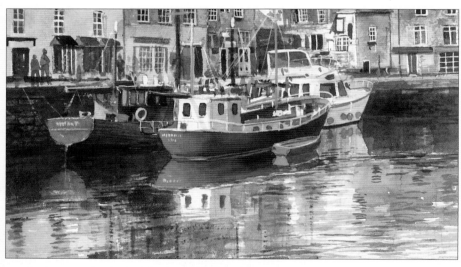

The boats make the harbour look busy, but there are not too many of them as this would distract you from the buildings. A good tip is to paint the reflections at the same time as the boats, while you have the correct colour already mixed on your brush. The reflections were mostly painted using the 13mm (½in) flat, then finished using the small detail brush.

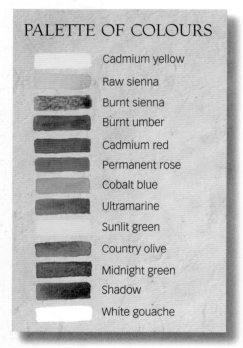

THE OLD CUSTOM HOUSE

The foliage brush was used for the texture on the buildings, and the ivy on the old Customs House. It was also used on the harbour wall, with the small detail brush used to pick out the finer details.

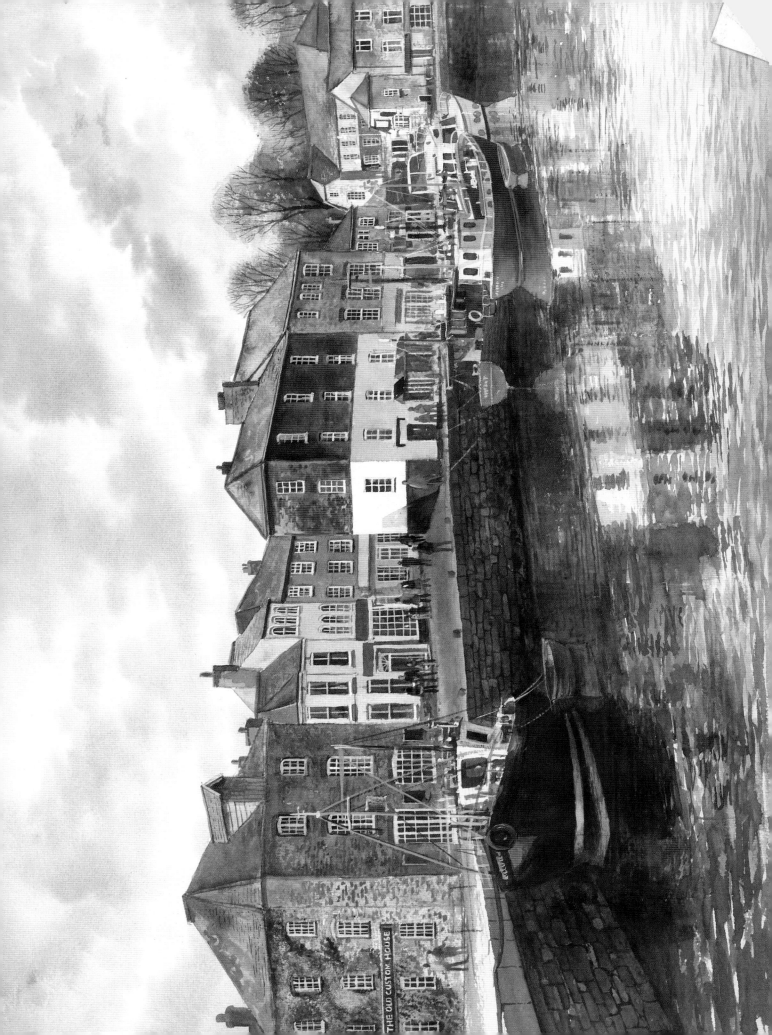

THE MOORING

When looking for inspiration on what to paint, the inland waterways and canals offer endless possibilities. This particular scene is on the Basingstoke Canal, a subject I have painted many times and in many different seasons. For this painting, I wanted a nostalgic glimpse of life back in the heydays of the canal network, with a working barge and a family taking time out to feed the ducks. The reference for the barge was supplied by the local canal preservation society.

This painting is very detailed, with plenty of opportunity to fiddle, so the small, medium and large detail brushes are essential.

If you prefer to create a modern-day scene, remove the bygone references – simply omit them when you transfer the image.

PALETTE OF COLOURS

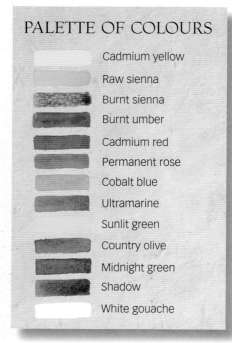

Cadmium yellow
Raw sienna
Burnt sienna
Burnt umber
Cadmium red
Permanent rose
Cobalt blue
Ultramarine
Sunlit green
Country olive
Midnight green
Shadow
White gouache

The light, pale bluish tones of the trees in the distance help to create a sense of depth in the painting. The foliage was created using the foliage brush.

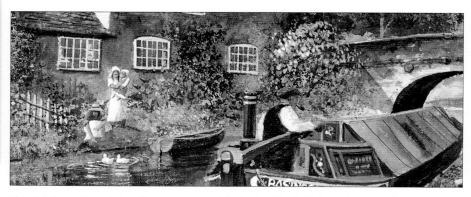

The details on the window frames were painted using the half-rigger brush and opaque white gouache. The figures and the ducks were painted using a mix of watercolour and gouache. Adding elements of life to a painting can change the whole feel of it; here they create the feeling of a bygone era.

The grasses and flowers in the foreground were masked with masking fluid using a fine brush and a ruling pen. Additional flowers can be added by mixing watercolours with a small amount of gouache to make the colour opaque, and then the flowers can be added over darker areas.

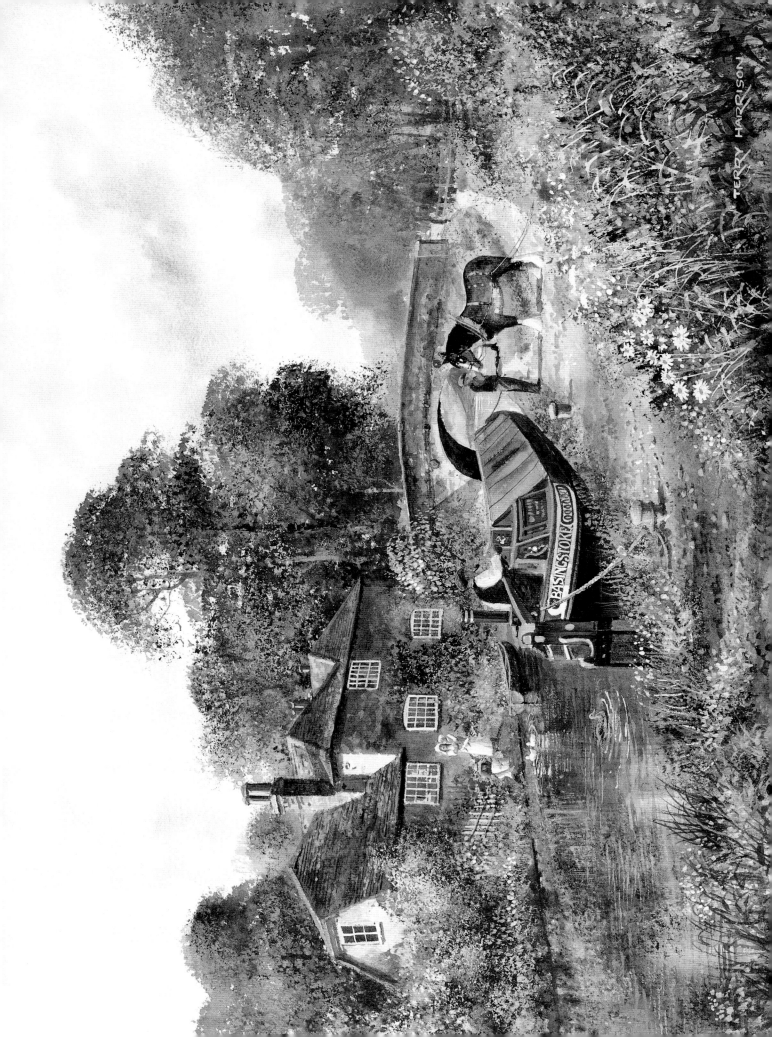

THE ROAD TO THE FARM

This painting is right up my street, or just down my lane (please excuse the pun)! This is the type of subject I love to paint: a summer's day, a winding road leading to a rustic farm, poppies everywhere, and to complete the scene, an old stile. This is quite a remote spot, and the road is a shortcut leading to the Basingstoke Canal.

Note how the road is not dead straight, but comes into the picture from the bottom left, then snakes around the trees and down to the farm. The road leads the viewer towards the focal point – the farm – inviting you to enter the painting.

PALETTE OF COLOURS

- Cadmium yellow
- Raw sienna
- Burnt sienna
- Burnt umber
- Cadmium red
- Permanent rose
- Cobalt blue
- Ultramarine
- Sunlit green
- Country olive
- Midnight green
- Shadow
- White gouache

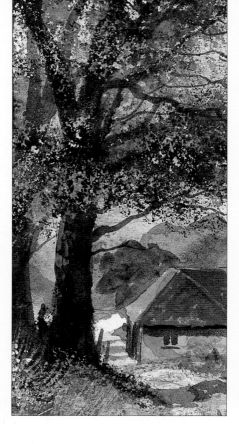

The main trees were painted using the golden leaf brush, then the branches were added where they would show in the gaps, giving the impression of full, summer foliage.

The overhanging tree and its shadow across the lane neatly frame the buildings.

The long, horizontal shadows that cross the lane help to frame the scene, creating a view to entice the onlooker into the painting. The stones on the track in the foreground were masked with masking fluid.

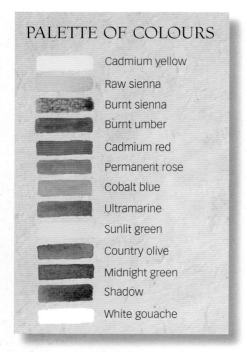

The stile and fence were masked using masking fluid along with the poppies. A ruling pen and masking fluid created the grasses in the foreground.

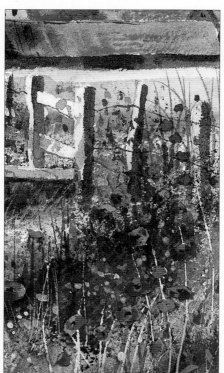

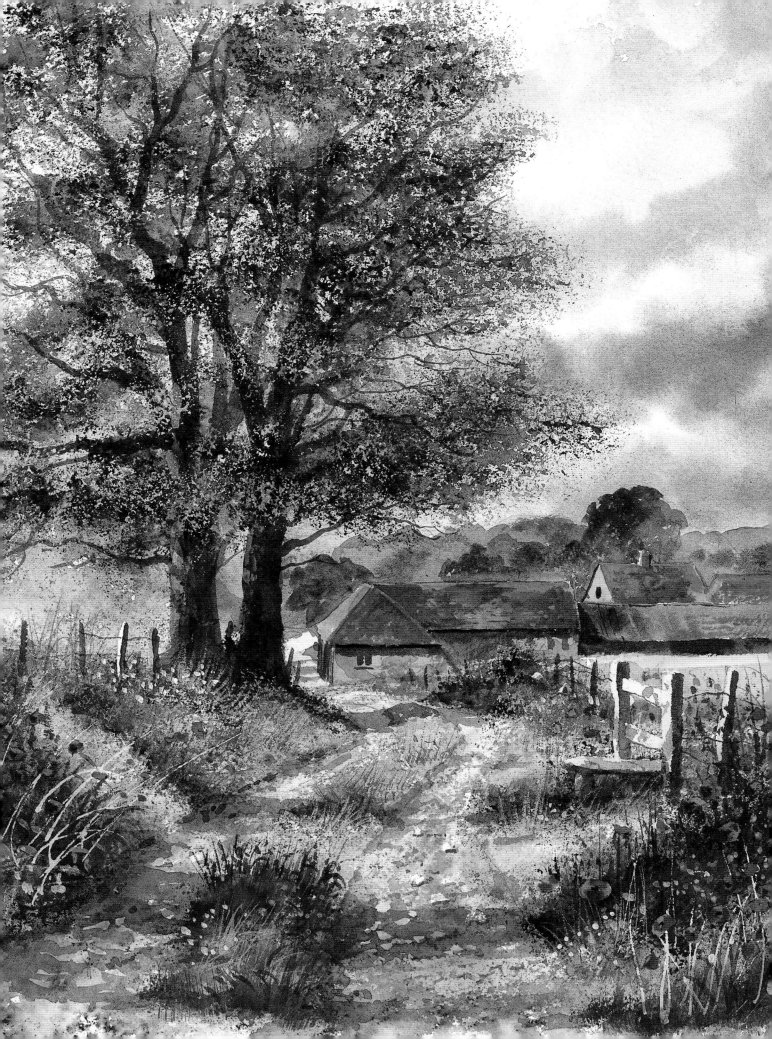

WATERSIDE WALK

One of my favourite paintings in this book, this tranquil waterside location is a place I know well. It was where I used to walk my dog and look for inspiration for painting, so each time I see this painting, it reminds me of my dog, Molly, and long walks with her in the country.

The footpath and fence lead the viewer from the shade down to the sunlit water's edge. The hazy trees on the opposite bank were painted wet into wet and are framed by the overhanging trees on either side of the footpath. The dark shadow across the path completes the framing.

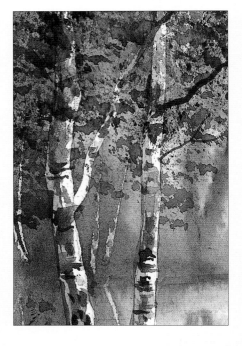

PALETTE OF COLOURS

- Cadmium yellow
- Raw sienna
- Burnt sienna
- Burnt umber
- Cadmium red
- Permanent rose
- Cobalt blue
- Ultramarine
- Sunlit green
- Country olive
- Midnight green
- Shadow
- White gouache

The silver birch trees were masked with masking fluid and the dark markings painted with the small detail brush once the masking fluid was removed. The lighter colour used on the tree trunks was a mixture of cobalt blue and a touch of burnt sienna to create a blue-grey. The darker markings were created using ultramarine and burnt umber. Care should be taken to leave the white of the paper on the right-hand sides of the tree trunks.

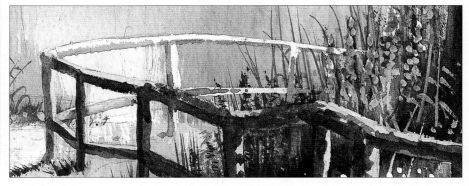

The dark shadows across the footpath help to link one side of the painting with the other and also provide a strong contrast with the white flowers in the foreground and the sunlight on the path.

Part of the fence is in the shade of the large tree on the right. The dark fence then becomes lighter as it continues into the sunlight, creating a sense of distance. The dappled shadows cast across the fence suggest sunlight coming through foliage.

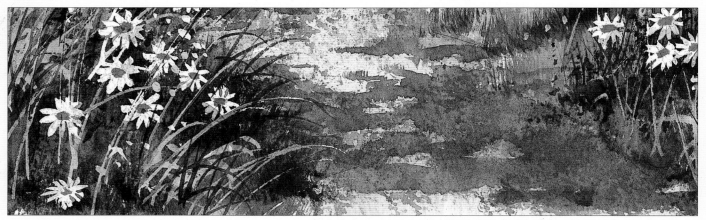

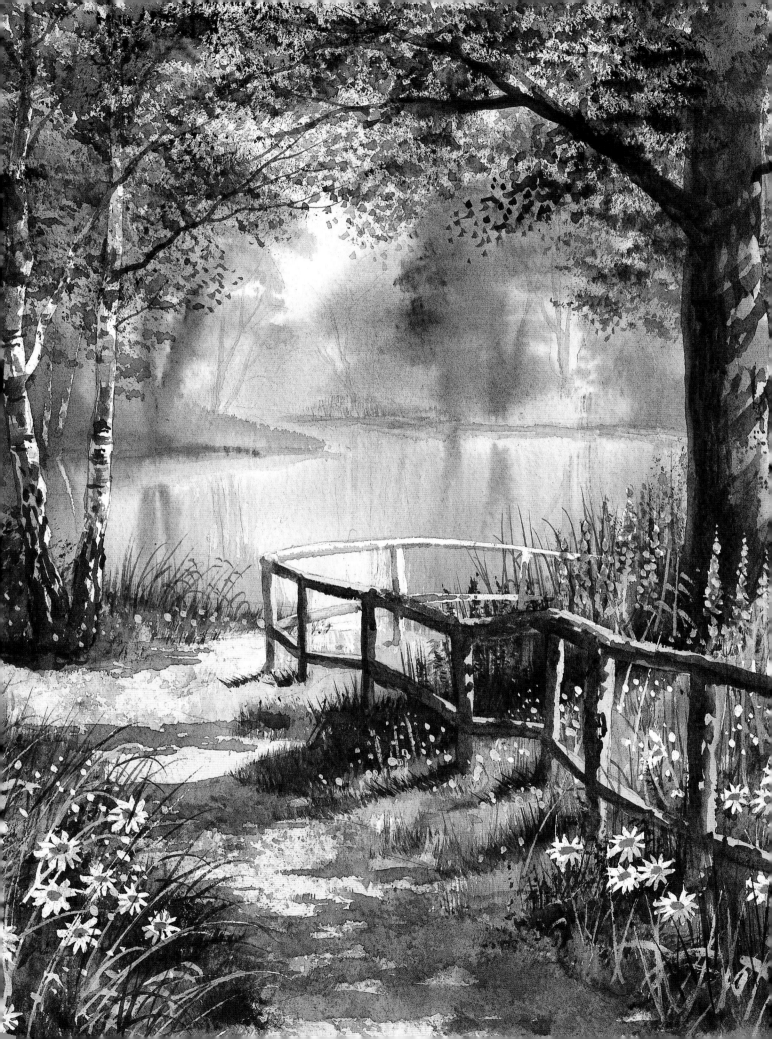

THE FERRYMAN'S COTTAGE

What I found appealing about this cottage was the way the original building has been extended with lovely old sheds and outhouses. The cottage is in fact a lock keeper's cottage on a canal, but after adding some boats to the opposite bank, I felt that I had invented a new scene, so it is now the Ferryman's Cottage. I often use photographs for reference, but I rarely copy them exactly. In this case, I used a photograph for the cottage but added some trees behind it to help bring the cottage forward to the middle ground. This on its own was not enough to make a finished painting, so I added the boats from another photograph to help fill the painting and create some interest.

OUTLINE
14

PALETTE OF COLOURS

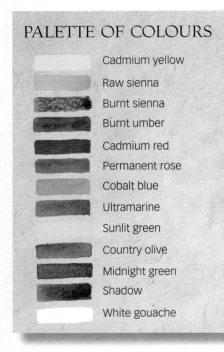

- Cadmium yellow
- Raw sienna
- Burnt sienna
- Burnt umber
- Cadmium red
- Permanent rose
- Cobalt blue
- Ultramarine
- Sunlit green
- Country olive
- Midnight green
- Shadow
- White gouache

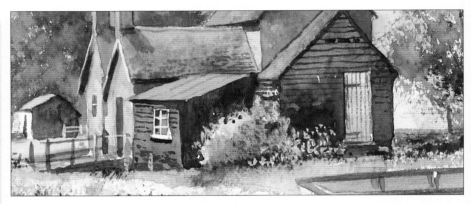

The details on the cottage and wooden sheds were painted using the half-rigger. White gouache was used on the end gables of the roof and on the window frames, and to add flowers over the dark woodwork of the lean-to.

Painting water is never easy, so take your time and do it in simple steps. Begin with a blue wash, using the same blue as the sky (ultramarine), then allow this to dry. The reflections are then painted over the first wash using short horizontal brushstrokes with a flat brush.

The riverbank is quite dark, which helps the lighter flowers stand out from the background. White gouache with a touch of cobalt blue was used to paint the ripples along the water's edge.

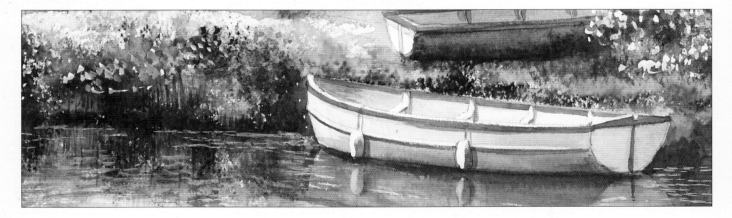

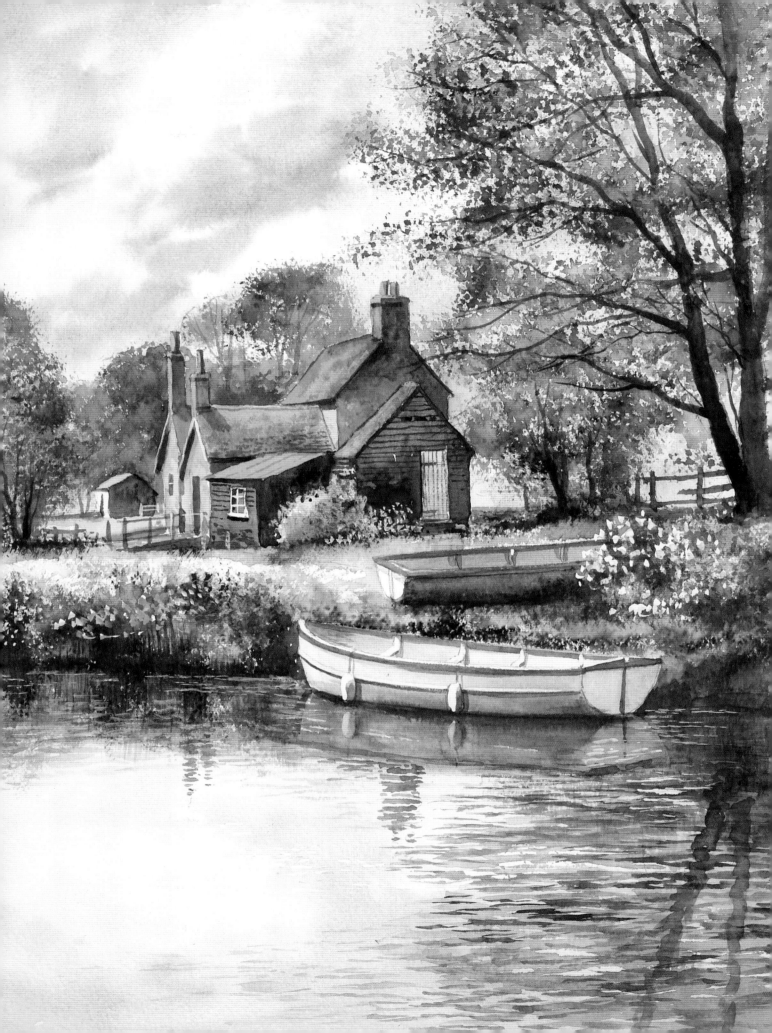

COOLING OFF

OUTLINE
15

Sometimes fate, or just good luck, steps in when you're struggling to find something to paint. With this particular painting, I had just found the perfect location and had positioned myself ready to photograph it when a horse and rider passed by and began to cross the ford, then the horse stopped and would not budge. The rider turned and apologised for getting in the way, then the horse turned as if to say, 'I want to be in the picture too!' I had, by chance, the perfect model. The feeling of summer is captured by the sunshine and light on the lane beyond the trees and on the bank. The trees in the distance were painted in soft focus using a wet into wet technique. The wild flowers in the foreground add a splash of colour to this idyllic scene.

PALETTE OF COLOURS

Cadmium yellow

Raw sienna

Burnt sienna

Burnt umber

Cadmium red

Permanent rose

Cobalt blue

Ultramarine

Sunlit green

Country olive

Midnight green

Shadow

White gouache

The wild flowers in the foreground not only add some colour and interest – they also form a link between the foreground and the riverbank opposite. The flower heads were masked using masking fluid and a small brush, and the grasses were masked using a ruling pen.

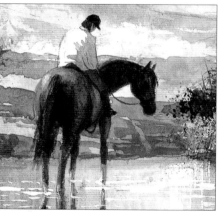

The horse and rider were a bit of luck – the tip is always to carry a camera for reference. I painted them directly on top of the dried background using a small detail brush.

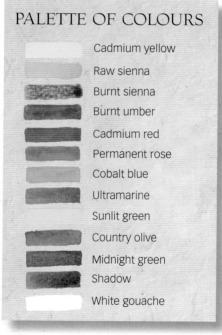

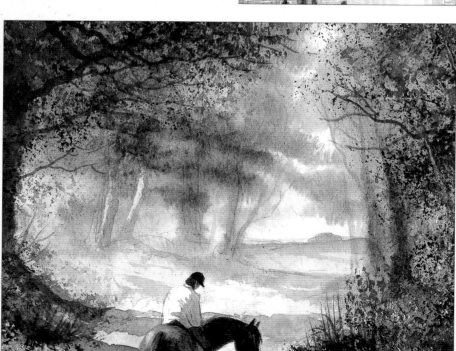

The centre of the painting is circular, like a porthole created by the overhanging trees and shadows across the lane. This leads you into the warm sunshine of the distant landscape.

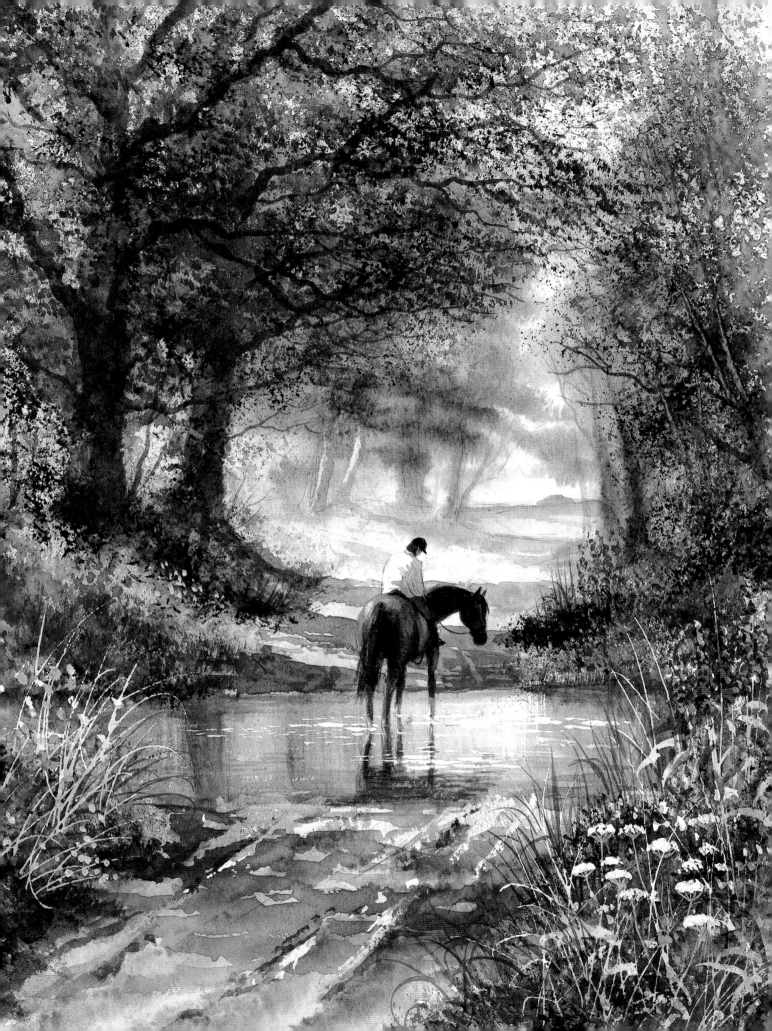

THE GREEN DOOR

This is a very simple but effective composition. The door is square on to the viewer so there is no need for any knowledge of the rules of perspective. A cottage door arched with roses is just one option; other suggestions for what to paint could be a sunlit Mediterranean door with bougainvillea overhanging the entrance, or perhaps something grander, such as a regency doorway in Dublin. This is a simple format and you can use the same techniques, a climbing plant around the door, texture and detail on the walls and potted plants either side of the doorstep in all three variations.

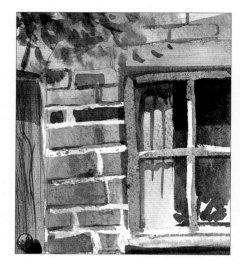

PALETTE OF COLOURS

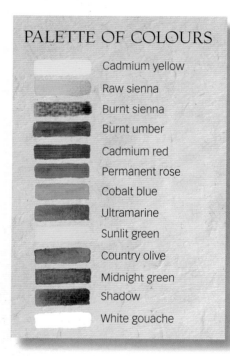

- Cadmium yellow
- Raw sienna
- Burnt sienna
- Burnt umber
- Cadmium red
- Permanent rose
- Cobalt blue
- Ultramarine
- Sunlit green
- Country olive
- Midnight green
- Shadow
- White gouache

Masking fluid was used on the wall for some of the mortar between the bricks, and the window frame was also masked. The shadow of the window frame falls across the curtain, giving an impression of depth.

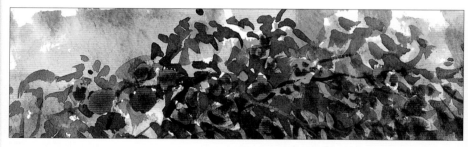

All the flower heads were masked, then the foliage was painted over the masked flowers using a medium detail brush. When the masking fluid was removed to reveal the white of the paper, I dropped in bright colours to produce a dazzling display of flowers to brighten any doorway.

The woodgrain on the rustic door was created using the wizard brush. The extra detail such as knots and panels can be added using the half-rigger. The shadow of the door recess and the climbing rose fall across the door. Use a dark green for the shadows, washing this over the door to give the impression of dappled sunlight. Use the colour shadow to continue the shadows on to the wall and under the climbing rose.

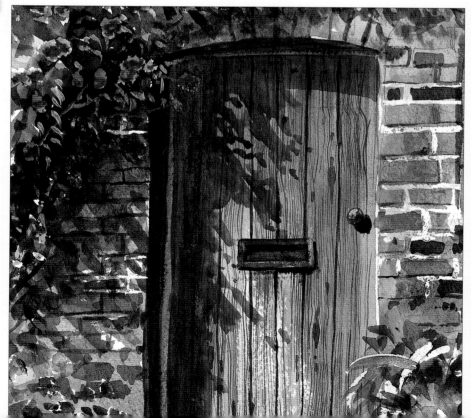

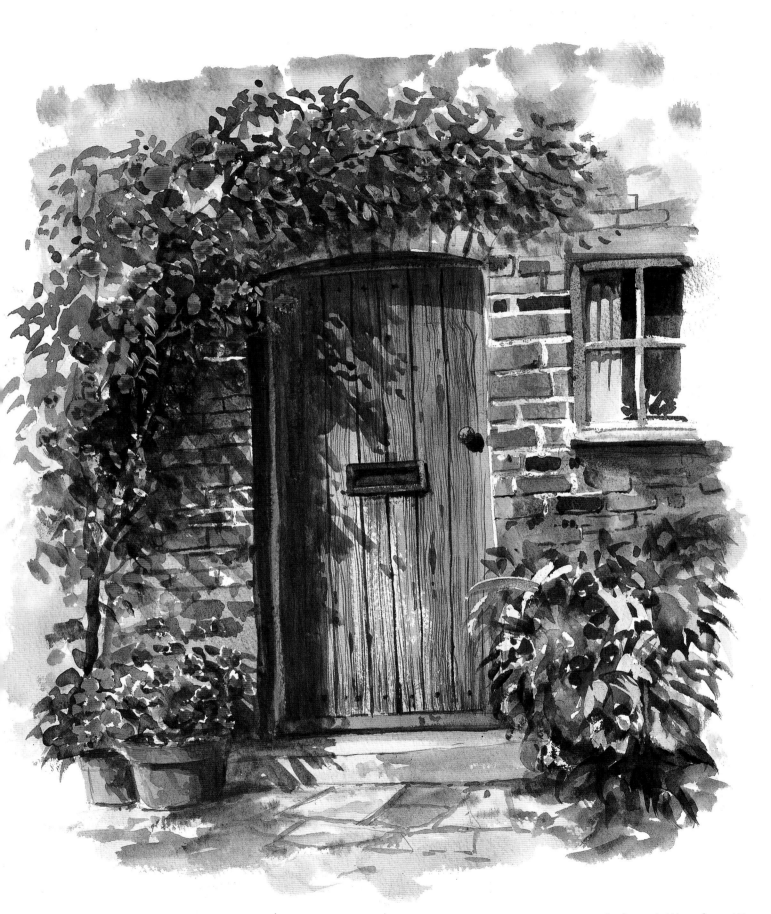

OFF THE BEATEN TRACK

Sometimes when you are searching for inspiration or a subject to paint, you have to take chances or be a little intrepid, as in this painting. I remember quite clearly stumbling through the undergrowth to get this view of the bridge – how we suffer for our art! If you take yourself off the beaten track, you might well find little gems like this to paint. When looking for a focal point, I often choose to paint some water, perhaps with a bridge, and then add some flowers to brighten the view. This painting could be converted into a beautiful bluebell wood with very little effort, simply by stippling cobalt blue with permanent rose on to the woodland floor, instead of light greens, using the foliage brush (see page 14).

PALETTE OF COLOURS

- Cadmium yellow
- Raw sienna
- Burnt sienna
- Burnt umber
- Cadmium red
- Permanent rose
- Cobalt blue
- Ultramarine
- Sunlit green
- Country olive
- Midnight green
- Shadow
- White gouache

The depth in this painting was achieved by having strong, dark trees in the foreground and as you move downstream, the trees become lighter and bluer as they get further away.

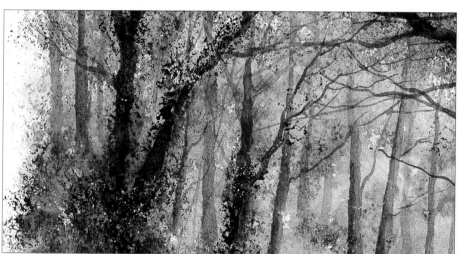

The sky was painted first, then the canopy of foliage was stippled on top, leaving little glimpses of blue through the trees. Use the golden leaf brush for the leaf effect and the ivy climbing up the trees.

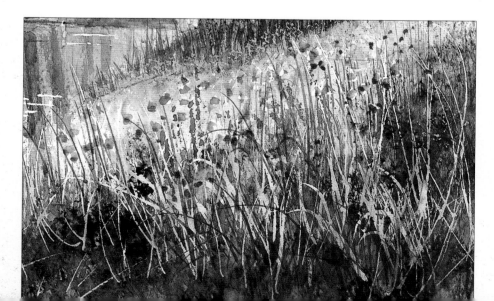

A ruling pen was used to apply masking fluid for the tall grasses in the foreground, and a brush was used to mask the flowers. When the masking fluid is removed, use permanent rose for the flowers and a wash of light green over the grasses.

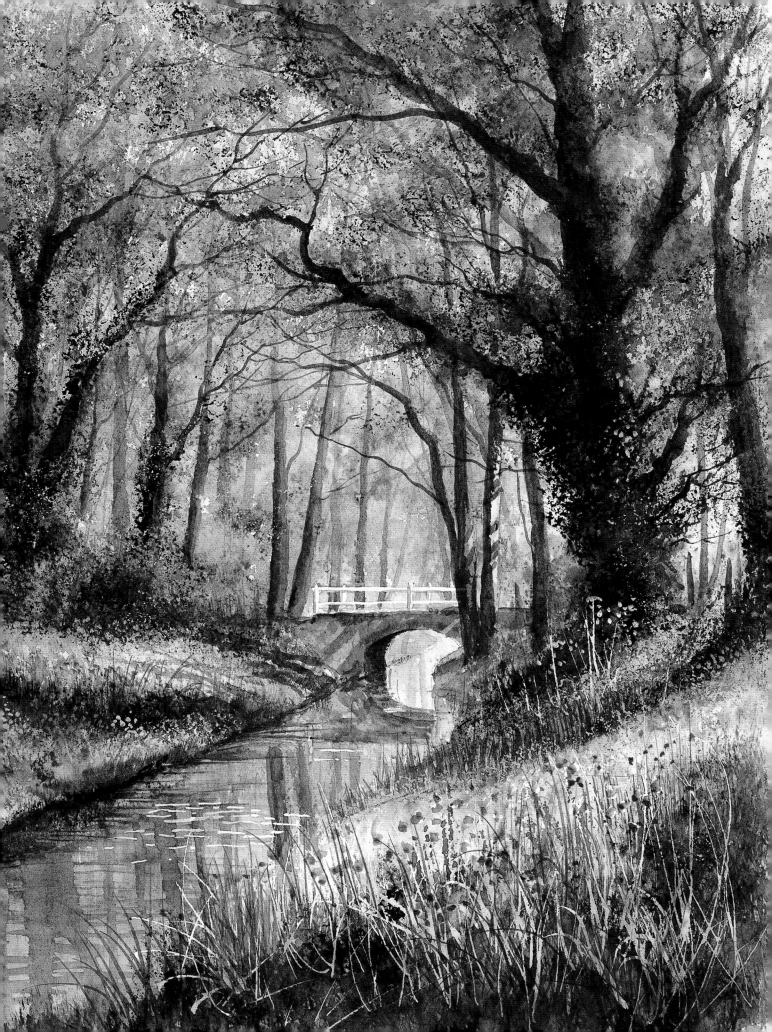

COURTYARD SHADE

There are many reasons for choosing to paint a certain subject; I love painting doorways as they are a simple subject, but each one reminds me of a particular time and place. This shady courtyard brings back happy memories of painting holidays in the south of France. What struck me about this scene was the sense of light and warmth. The dark of the overhead tree and the shade in the right-hand corner contrast strongly with the sunlight on the wall and the table and chairs. The only thing missing from this painting is a bottle of wine and glasses on the table – but these can be added later!

PALETTE OF COLOURS

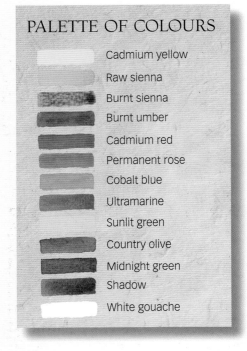

- Cadmium yellow
- Raw sienna
- Burnt sienna
- Burnt umber
- Cadmium red
- Permanent rose
- Cobalt blue
- Ultramarine
- Sunlit green
- Country olive
- Midnight green
- Shadow
- White gouache

The detail on the louvre doors requires a lot of masking, using a ruling pen and a straight edge. An alternative is to use white gouache and a small brush.

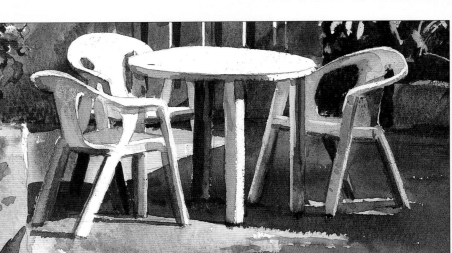

Mask the table and chairs with masking fluid using a small brush. This needs to be done carefully, as neat, crisp lines will make the furniture more inviting. It is also possible to tidy up the edges later using some white gouache. Not all of the furniture is in the sunlight, but the shading is lighter in tone than the background shadows.

The golden leaf brush was used for the foliage of the tree, then some small leaves were added to create detail.

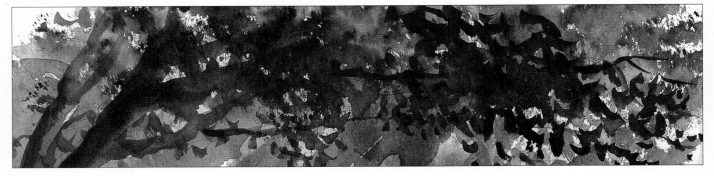

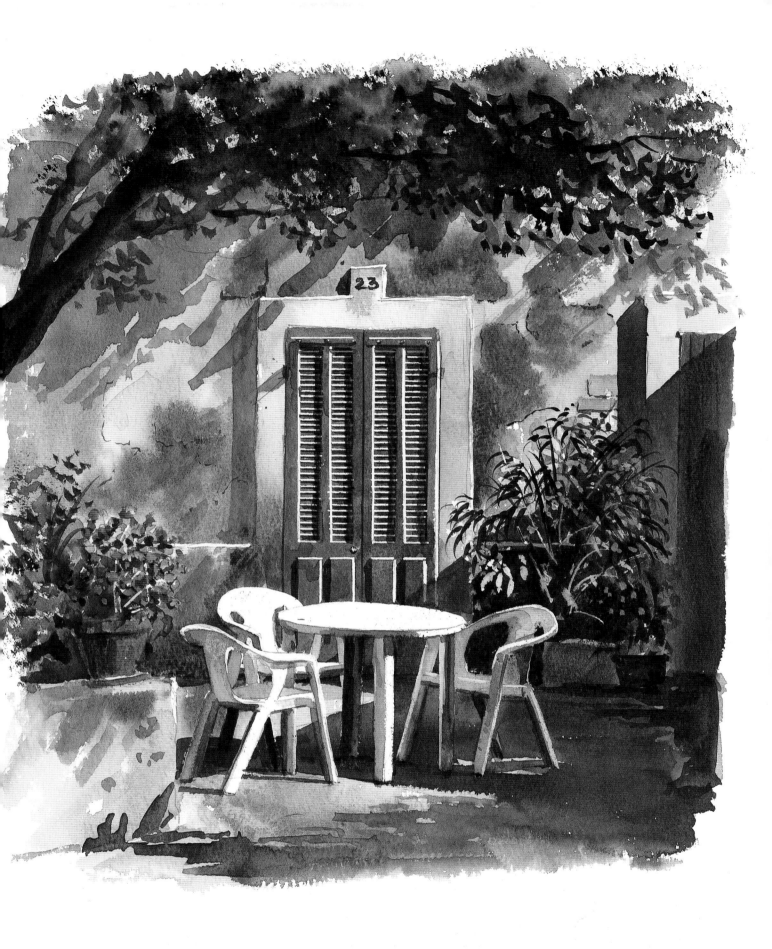

HARD DAY'S WORK

This small farmstead is in the foothills of the Blue Ridge Mountains in North Carolina. I have never seen so many barns in one area, and I was spoilt for choice, so why choose this one to paint? It was typical of the region, a weather-beaten wooden barn with a rusting tin roof, not too run-down, but rustic. I wanted more than just a painting of a barn, so I added a small tractor at work in the field to depict a simpler, slower pace of life. The flowers in the foreground add some extra colour.

PALETTE OF COLOURS

- Cadmium yellow
- Raw sienna
- Burnt sienna
- Burnt umber
- Cadmium red
- Permanent rose
- Cobalt blue
- Ultramarine
- Sunlit green
- Country olive
- Midnight green
- Shadow
- White gouache

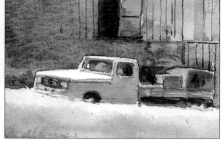

This is a nice little touch in the painting; I like the way the sun catches the bonnet (or hood) and roof of the pick-up truck; this is a simple shape but very effective. The detail of the barn was painted using the half-rigger.

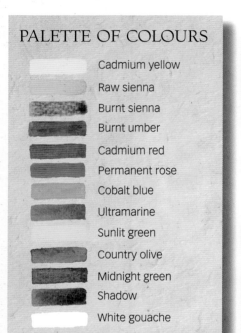

The tractor was carefully painted to include as much detail as possible. You don't have to be an expert on farm machinery to paint one – just paint what you see, not what you think you see. White gouache was used to highlight the tops of the wheels and the head and shoulder of the farmer.

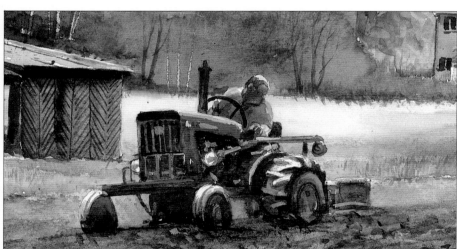

The background trees are painted quite loosely using a wet into wet technique and the golden leaf brush. Begin with the light blues and pale greens, then move to the left, getting slightly darker until you reach the tin roof of the barn. It is important that the greens are really dark at this point, as it is the dark tones of the trees that make the sunlit roof stand out.

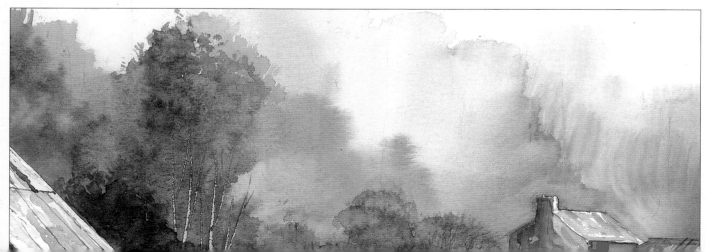

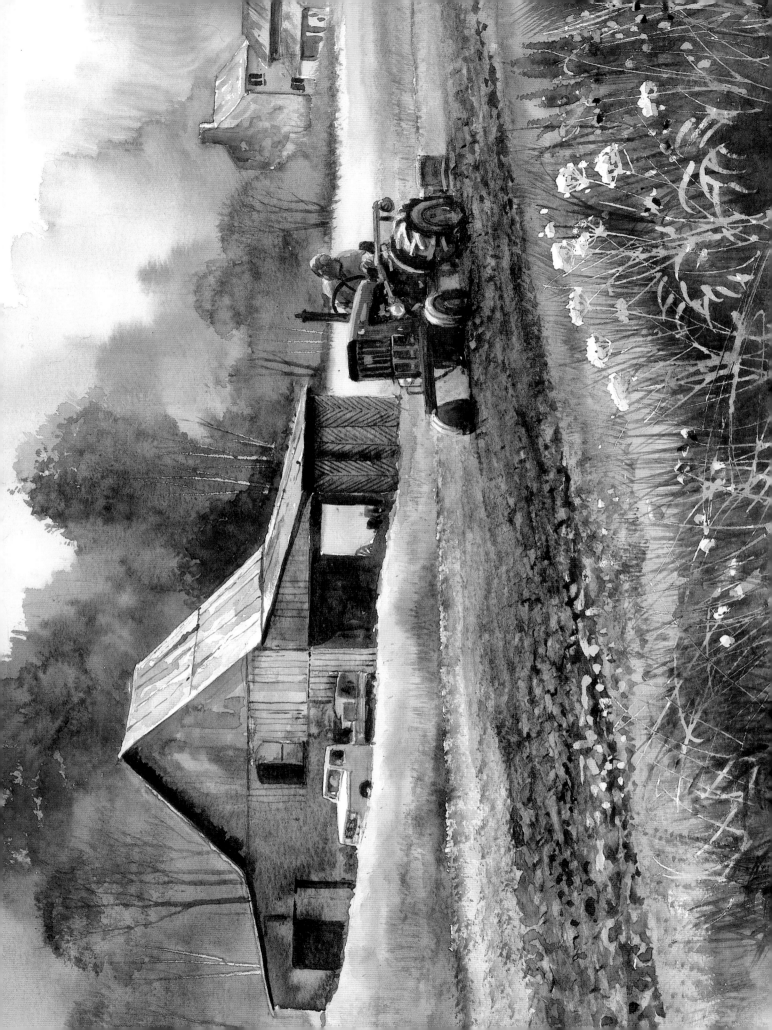

CASTLE COMBE

Castle Combe has been called 'the prettiest village in England' with good reason; this is the village that time forgot. It could be a film set, and in fact is often used as one. Choosing a view to paint is the problem, as there is so much to tempt you. For this painting I have opted for what I think is the best view, but I have moved one or two of the buildings to fit the composition, for example, the church was moved to the right to be included in the painting. This is called artistic license! If you change things around a bit to make a better painting, I am sure no one will notice – I do it all the time.

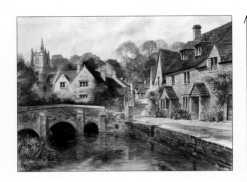

PALETTE OF COLOURS

- Cadmium yellow
- Raw sienna
- Burnt sienna
- Burnt umber
- Cadmium red
- Permanent rose
- Cobalt blue
- Ultramarine
- Sunlit green
- Country olive
- Midnight green
- Shadow
- White gouache

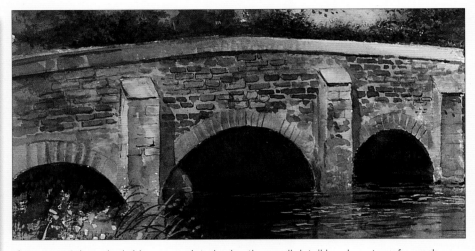

The stonework on the bridge was painted using the small detail brush on top of a wash of colour. The bridge is partly in the shade and is darker in tone than the main buildings. Painting the bridge and the river darker makes the brighter riverside cottages the dominant part of the painting.

The distant trees need to be fairly soft and not too dark. The foliage brush was used to stipple the canopy of leaves and the half-rigger was used to paint in the tree trunks and branches.

The warm-coloured sandstone cottages are a major feature in this part of the south Cotswolds. Getting the right colour is essential: I have used raw sienna, some burnt sienna and a dash of permanent rose. The roof tiles are darker, so begin with burnt sienna and burnt umber with a touch of ultramarine, and then add raw sienna if needed.

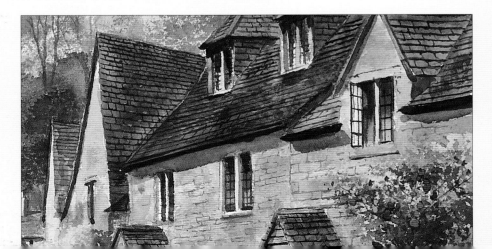

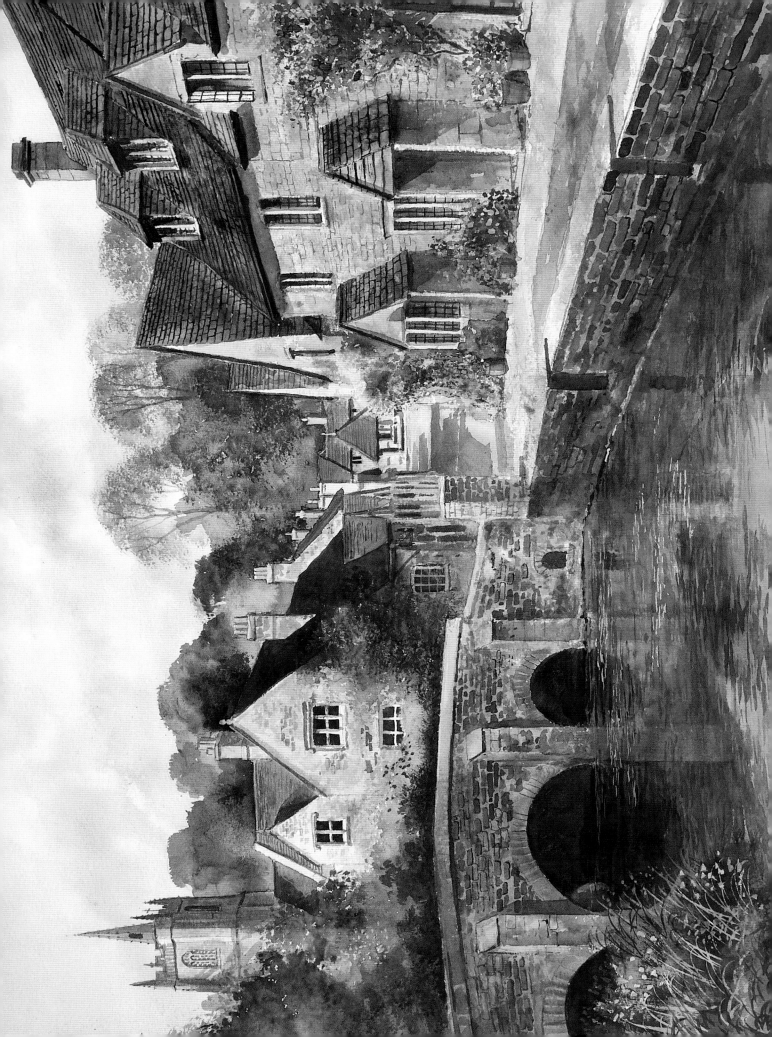

THE VILLAGE GOSSIPS

This charming thatched cottage is in the heart of Hampshire near Andover. The cottage garden is just bursting with summer flowers and colour, so much so that they almost swallow the cottage, leaving just the roof and windows like eyes peering out of the foliage. This painting is not just about the buildings; adding the girls chatting in the lane and giving it the title *The Village Gossips* gives the painting a brand new meaning. The composition draws you to the focal point – the girls. The slope of the roof, the picket fence and lane all lead you to the same spot. If the gossips are not to your taste, why not change them for some chickens or someone walking a dog.

PALETTE OF COLOURS

- Cadmium yellow
- Raw sienna
- Burnt sienna
- Burnt umber
- Cadmium red
- Permanent rose
- Cobalt blue
- Ultramarine
- Sunlit green
- Country olive
- Midnight green
- Shadow
- White gouache

The temptation is to paint a thatched roof a yellow straw colour, but though they may well start off that colour when first thatched, soon the colours fade to many different shades of grey – never yellow. I have used a small amount of raw sienna to start with, then added a grey mix of burnt sienna and cobalt blue using the wizard brush.

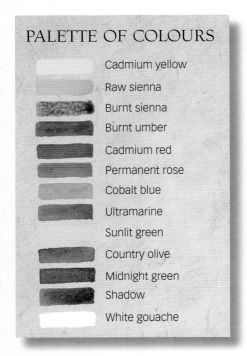

The picket fence was masked with masking fluid, then the background colour of a very dark midnight green was painted over the fence. This is important as the dark green contrasts with the white of the fence posts, making them stand out. Dappled shadows are then painted over the fence using a pale cobalt blue.

With figures I always start with the flesh tones: raw sienna and permanent rose. One girl is dressed in blue (cobalt blue), the other in pink (permanent rose). The bonnet ribbons match the dresses. The smocks are white, one tinted with blue, the other with a touch of raw sienna. I used burnt umber for the hair and boots and the baskets are coloured with burnt sienna. To finish, paint a shadow under the girls with shadow colour.

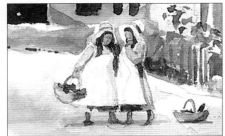

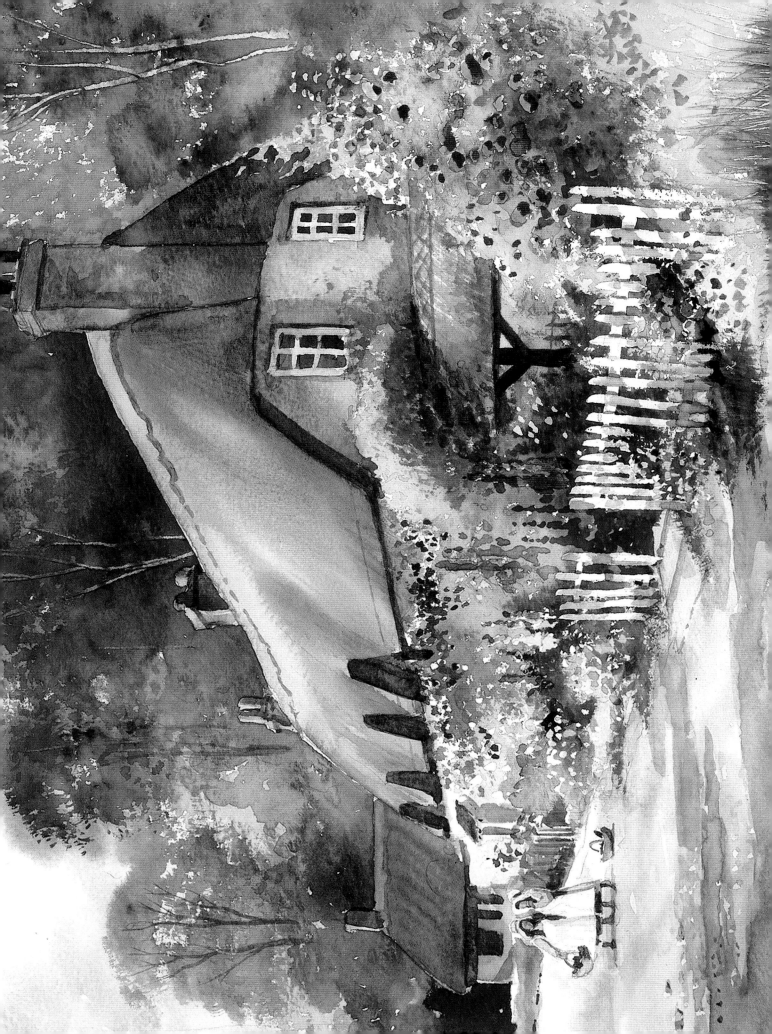

CHATTING ON THE PORCH

I came across this old store while out barn hunting near Boone in North Carolina. It was like stepping back in time; if it wasn't for the pick-up truck and cars you would think you were in an old film set. I love painting buildings with character and this place had everything: a faded weatherboarding facade and old tin roof, the Esso sign and disused petrol (gas) pump are all reminders of yesteryear. The flag flying over the store confirms that this can only be the USA. I could not resist adding two old-timers passing the time of day on the porch and chickens scratching around in the dirt.

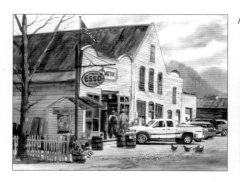

PALETTE OF COLOURS

- Cadmium yellow
- Raw sienna
- Burnt sienna
- Burnt umber
- Cadmium red
- Permanent rose
- Cobalt blue
- Ultramarine
- Sunlit green
- Country olive
- Midnight green
- Shadow
- White gouache

To make the store facade look a little weathered, begin with a wash of raw sienna, add some cobalt blue and let it dry. Using the half-rigger, paint the weatherboards with a light grey mixed from cobalt blue and burnt sienna.

The rusting tin roofs were painted wet into wet. Wet the roof area with a wash of clean water using a large detail brush, then drop the rust colours into the wet. Begin with the light colours and then add the darks. I used burnt sienna, burnt umber and some ultramarine.

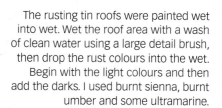

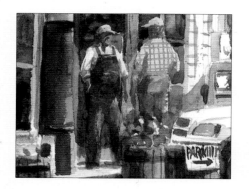

Adding life to a painting can really make a difference, but don't make figures too large as they will dominate the painting. When painting figures, I begin with the head and arms, using raw sienna with permanent rose. For the right-hand man's shirt I used raw sienna with checks of burnt umber. For the white shirt I used white gouache, and the jeans were painted using ultramarine and burnt umber. The hats are light against a dark background to help them stand out, and for these I used white gouache with a touch of raw sienna.

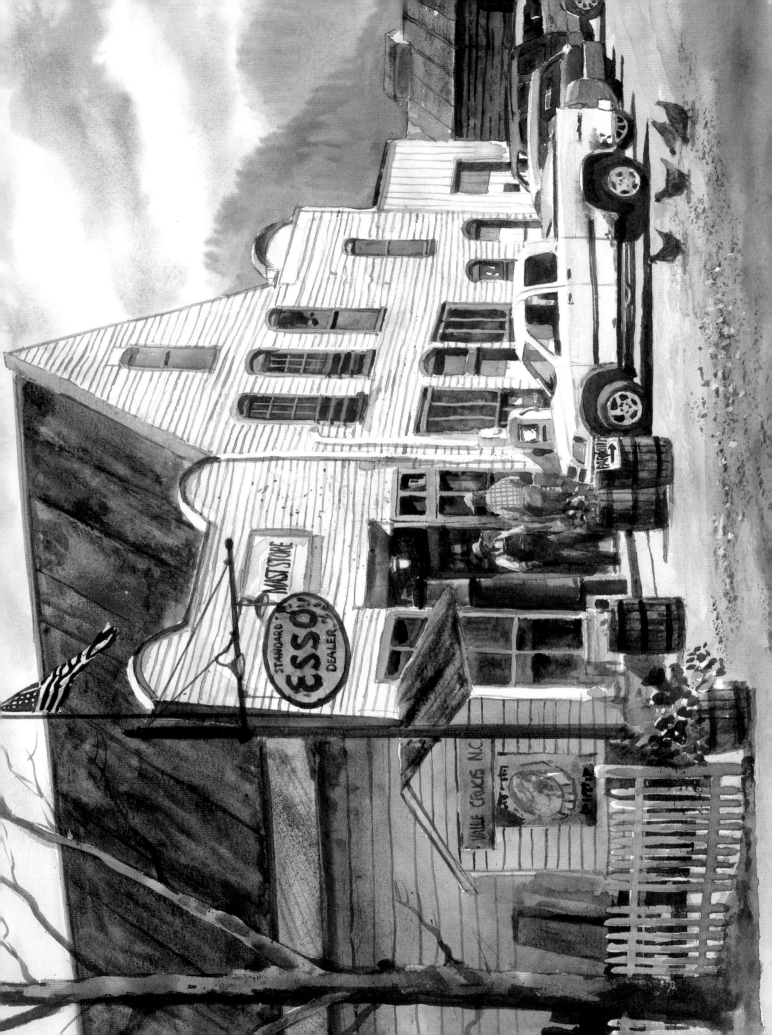

ANOTHER WINTER

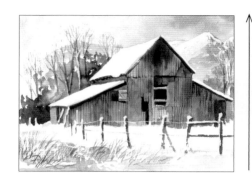

Looking at some barns, it makes you wonder if they will last another winter. This rustic barn has seen better days; maybe that is its charm. There is something about rustic barns that makes them irresistible to some artists. If you are searching for ideas for what to paint, choose a barn in any season – you can't go wrong. This particular barn is quite dark in tone and contrasts strongly with the white of the snow. Masking fluid plays a big part in the success of this painting; it allows you to be quite free and loose with your washes, but retains and protects the main elements of the painting. The main masked areas are the mountaintops, the snow on the trees, the roof of the barn, and in the foreground the fence posts and wire, and finally the snow-covered grasses.

PALETTE OF COLOURS

- Raw sienna
- Burnt sienna
- Burnt umber
- Permanent rose
- Cobalt blue
- Ultramarine
- Shadow
- White gouache

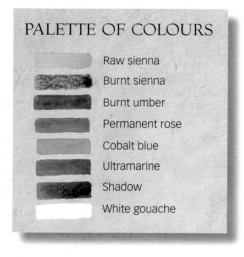

The snow on the treetops was masked using kitchen paper soaked with masking fluid then lightly dabbed on. Some of the tree trunks and branches were also masked. Once this was dry, I painted the sky, then the dark areas of shadow colour and burnt umber were painted over the trees using a large detail brush. When this was dry, the details such as the trunks and branches were added using the half-rigger. When all this paint had completely dried, I was able to remove the masking fluid from the trees.

The front of the barn was painted wet into wet using only three colours: burnt umber, burnt sienna and ultramarine. Begin with a fairly wet wash of pale burnt umber, then drop the dark colours into the wet paint. For the very dark areas such as the gable at the top of the barn, I used burnt umber and ultramarine. This might look a mess at this stage, but be brave and stick with it – all will be well once the details are added. A dark mix of burnt umber and ultramarine was used for the detail and the medium detail brush for the eaves under the roof, the doors and the dark gaps in the woodwork. A half-rigger was used for the vertical planking.

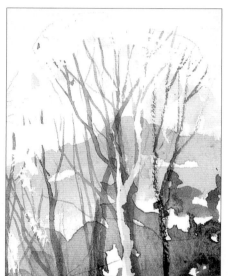

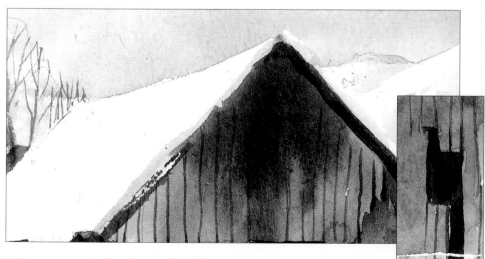

A ruling pen with masking fluid was used for the wire on the fence and the grasses in the foreground. For the snow-capped fence posts I applied the masking fluid with a brush.

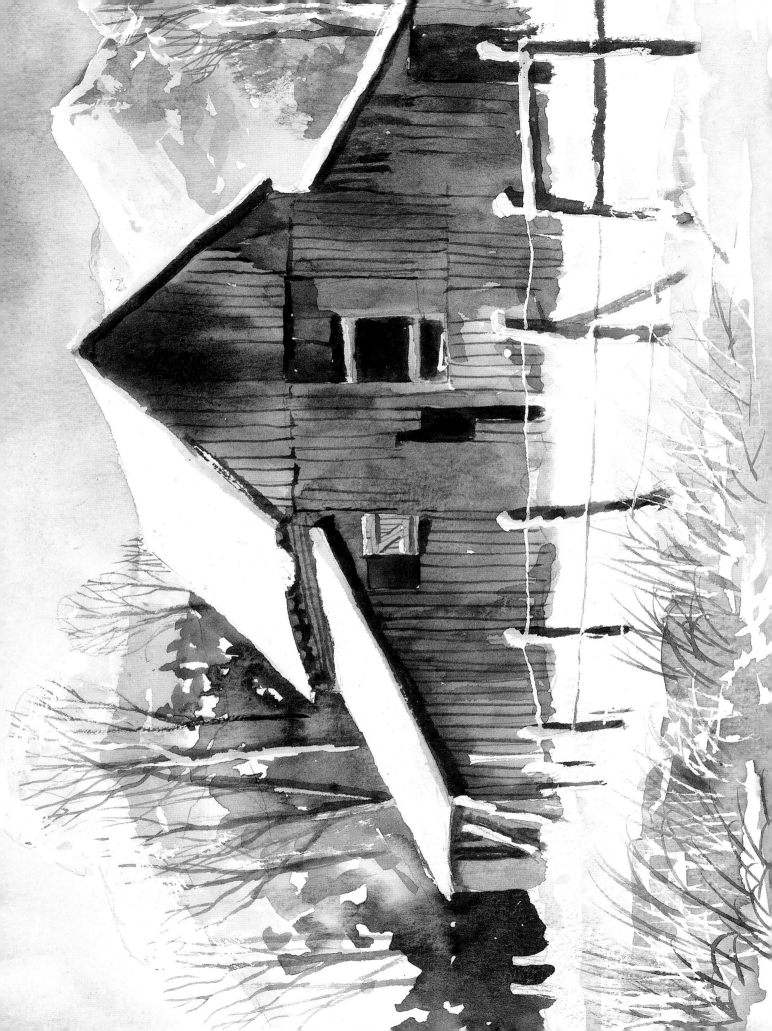

THE MOUNTAIN STREAM

The main feature of this painting, apart from the stream, is the packhorse bridge; a marvellous subject for a focal point, with lots of interest and fine detail on the stonework. The bridge also acts as a link between one side of the painting and the other, and invites the viewer to look through the archway and into the distance. The mountains beyond also draw the eye into the painting. There are plenty of techniques employed in this painting to test the artist, such as a wet into wet sky, the fine detail on the bridge, painting running water with reflections and painting my 'credit card' rocks.

To paint rocks using my 'credit card' technique, block in the shapes with raw sienna and a little country olive, used fairly dry. Cover this over with burnt umber and ultramarine, then scrape away some of the top layer with a plastic card to create texture, leaving some darks.

PALETTE OF COLOURS

- Raw sienna
- Burnt sienna
- Burnt umber
- Cobalt blue
- Ultramarine
- Country olive
- Shadow
- White gouache

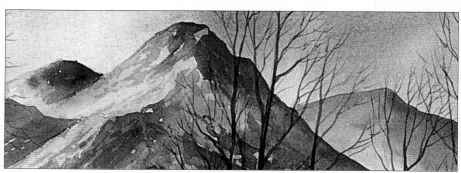

Do not attempt to paint the mountains until the sky is dry. Begin with the furthest peak and use a medium detail brush with a first wash of raw sienna and a touch of cobalt blue. Paint this over the whole of the mountain, then drop in shadow colour along the top ridge of the mountain, allowing the paint to run and merge into the first colour. When the first mountain is dry, repeat the same technique on the main mountain.

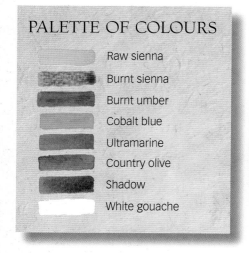

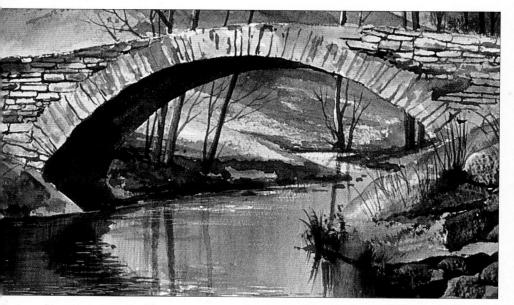

The water and reflections were painted using the wizard brush and similar colours to the mountains and trees above. White gouache mixed with cobalt blue was used to paint the ripples in the water.

I painted a pale grey wash of cobalt blue and burnt sienna over the stonework on the bridge, then I dropped some burnt umber and raw sienna into the wet paint, then a touch of country olive to depict the moss. The detail on the bridge was painted using the half-rigger once the first wash had dried. The background trees were also painted using the half-rigger after which foliage was added on some of the trees using the foliage brush.

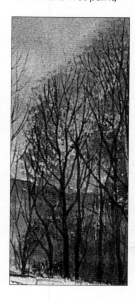

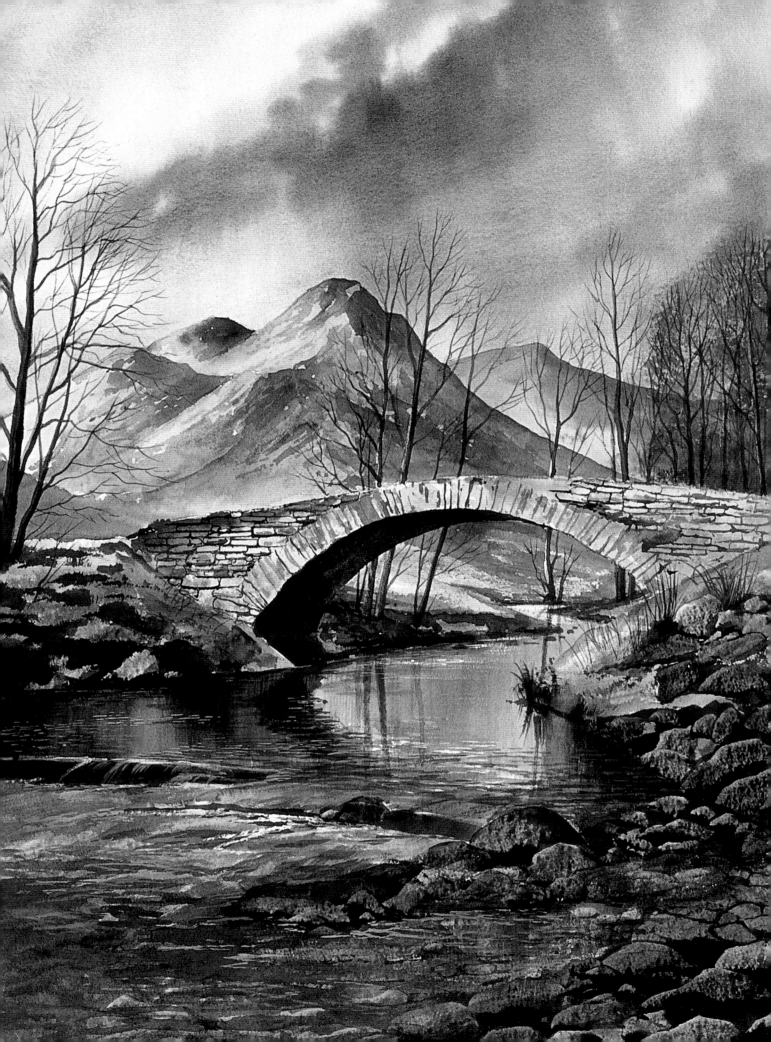

INDEX

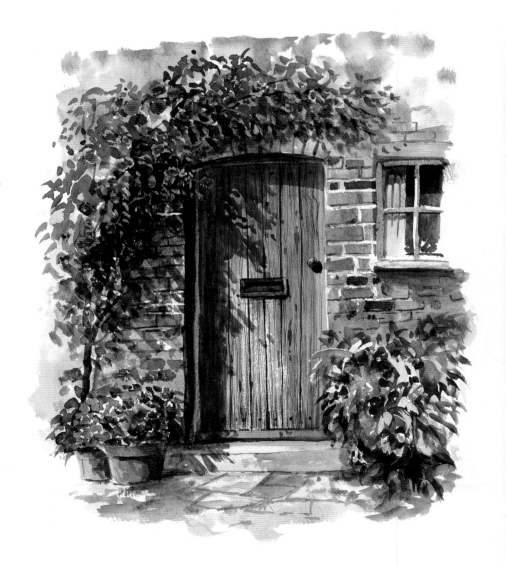

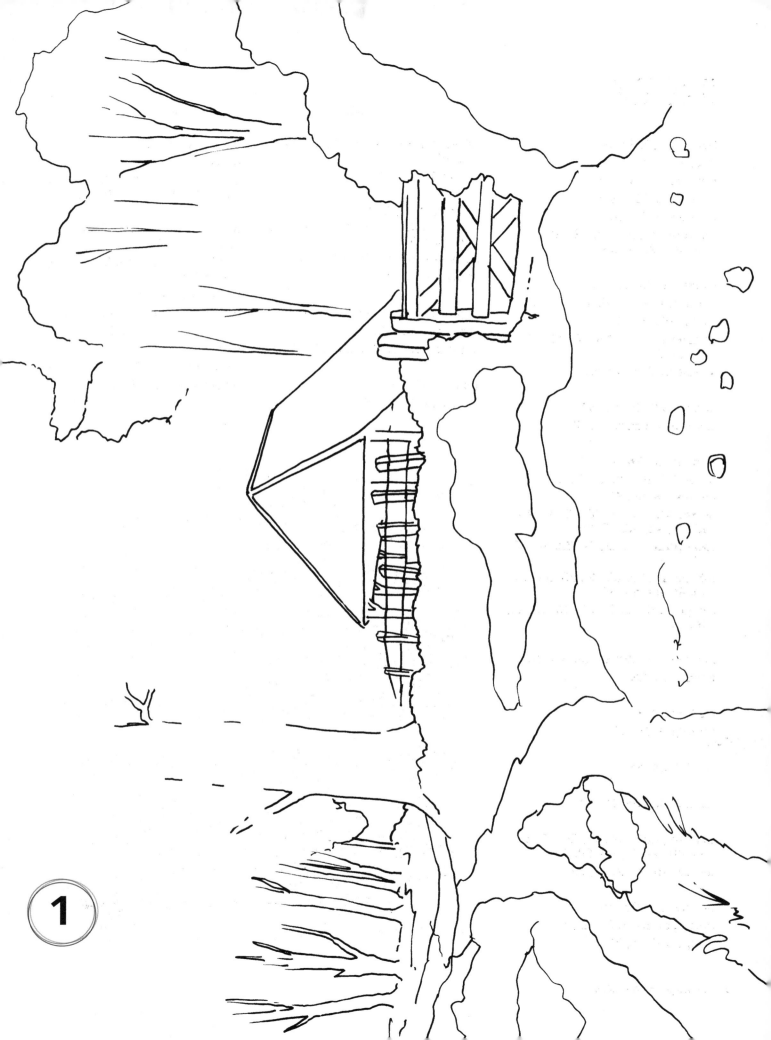

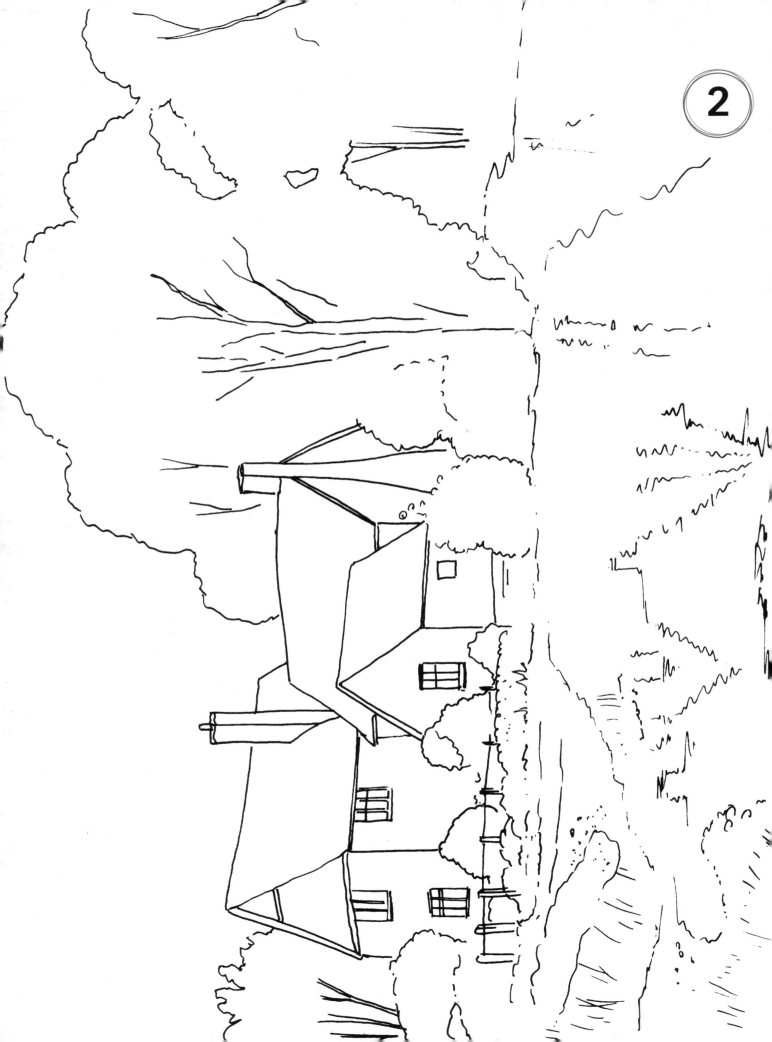

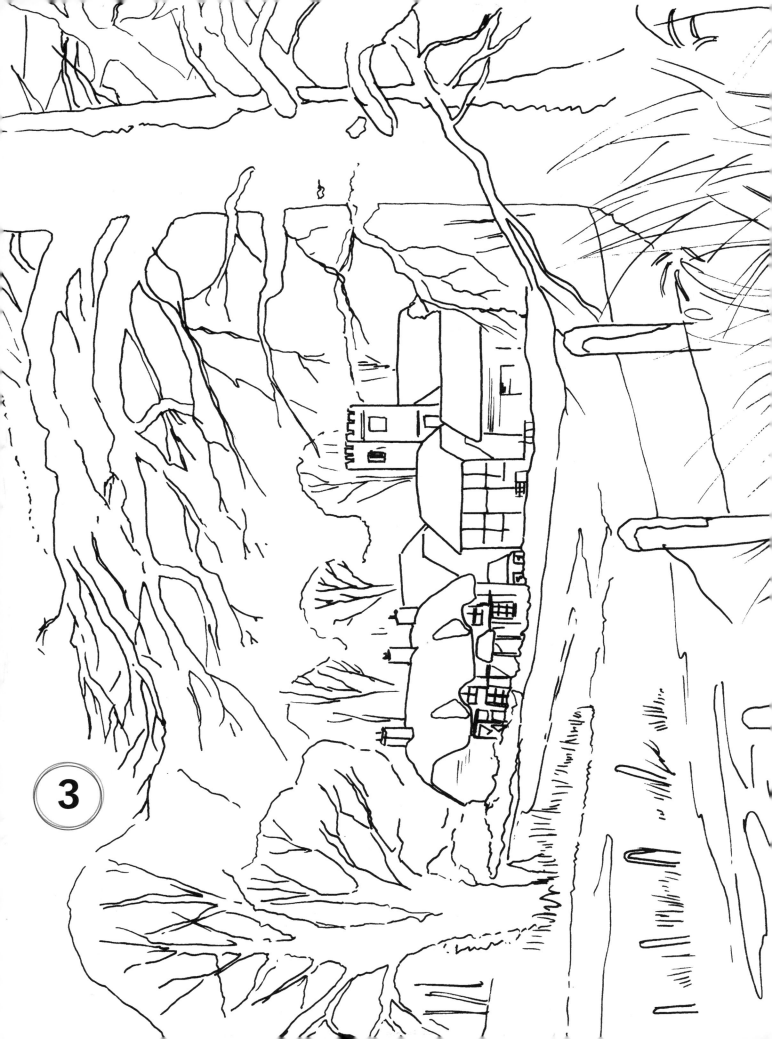

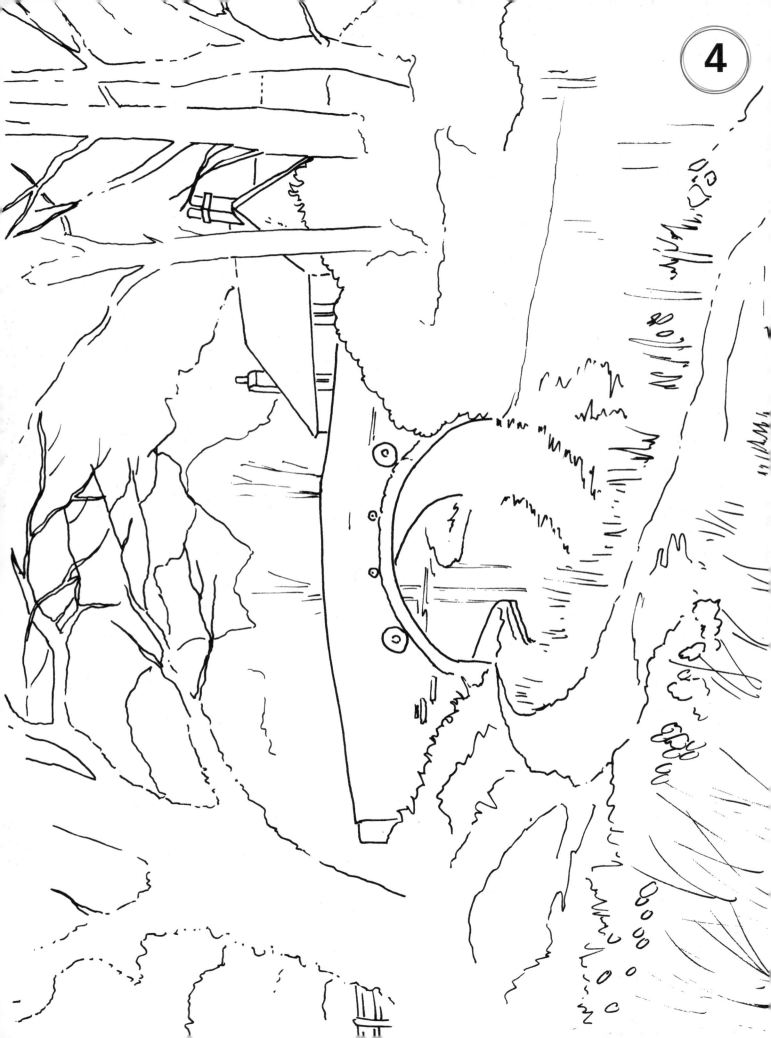

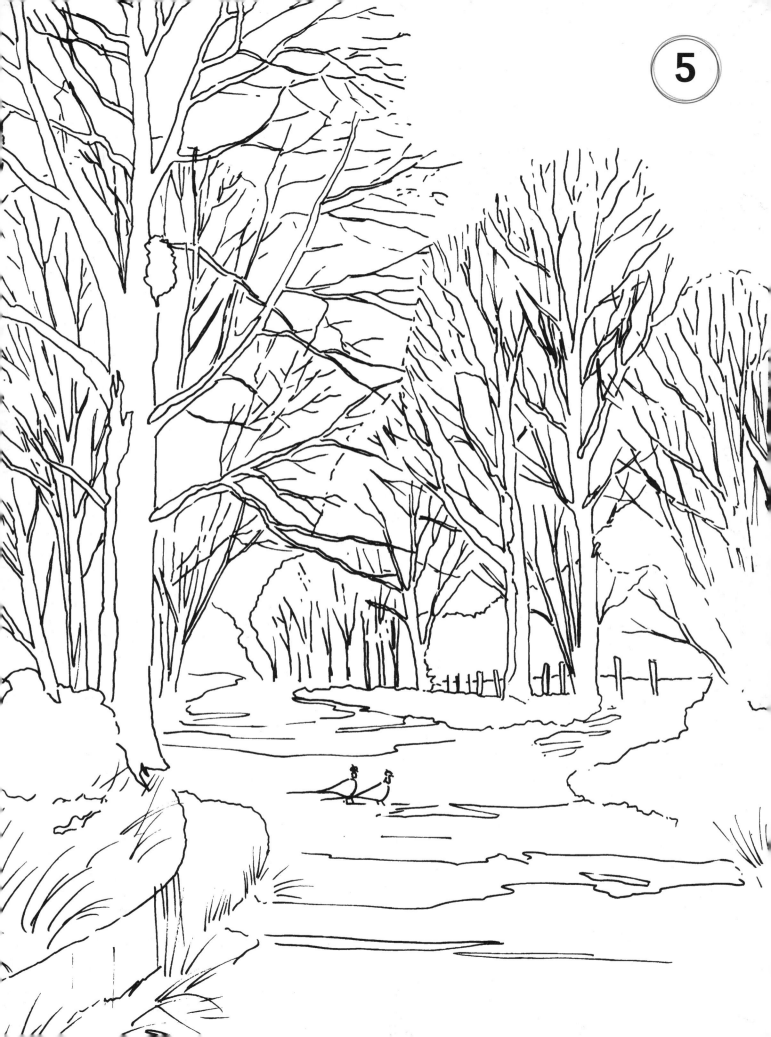

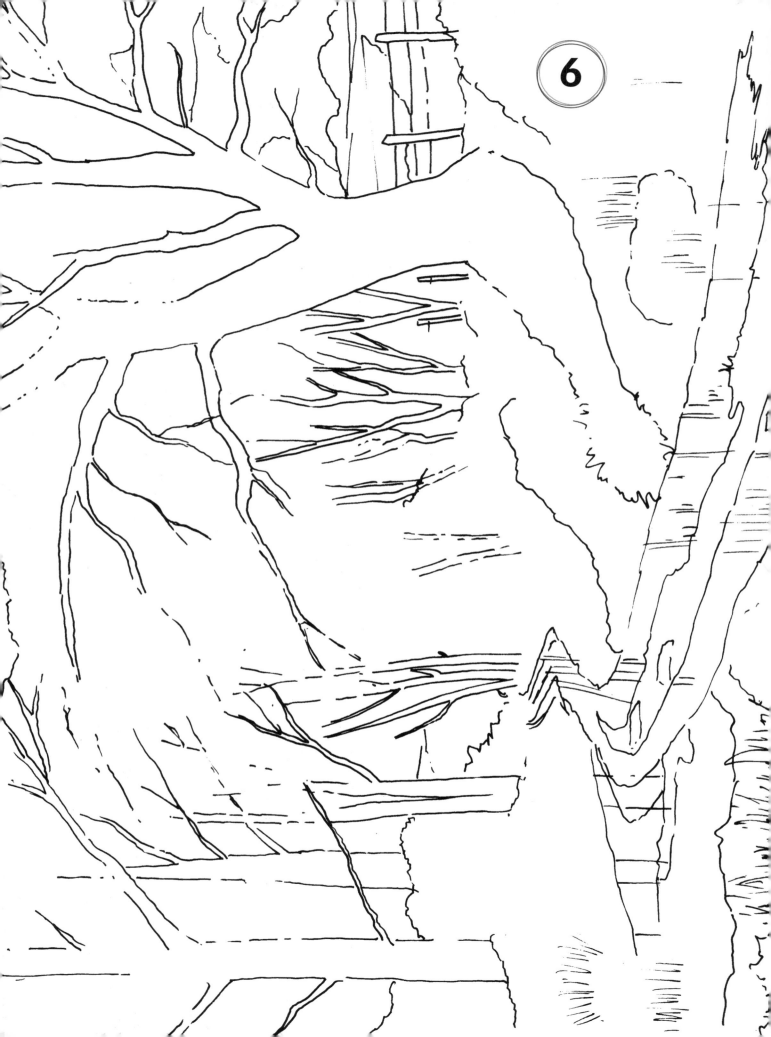

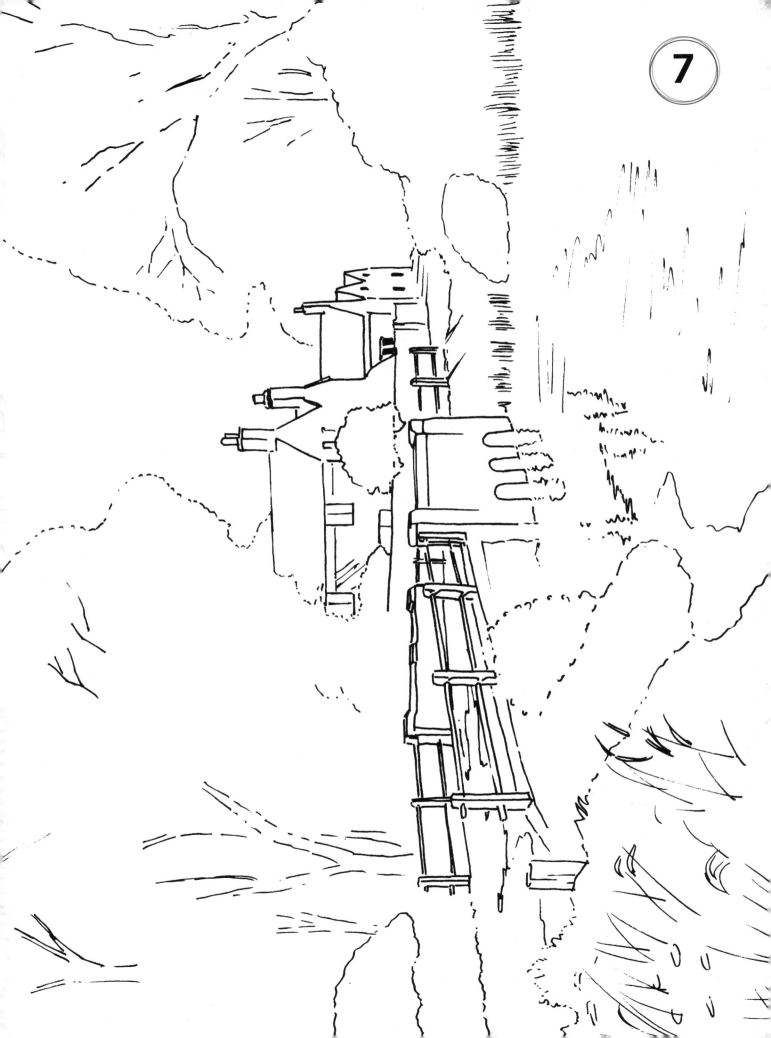

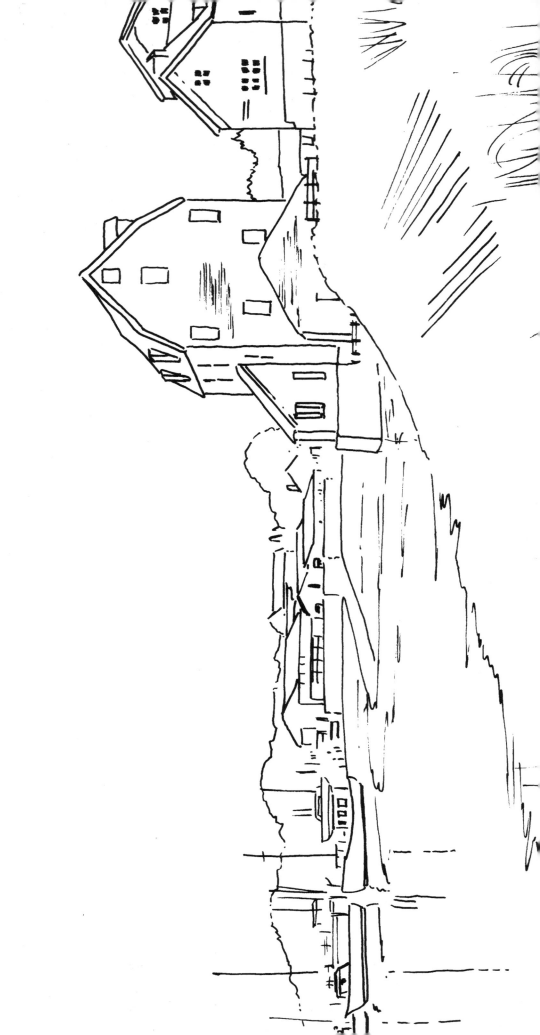

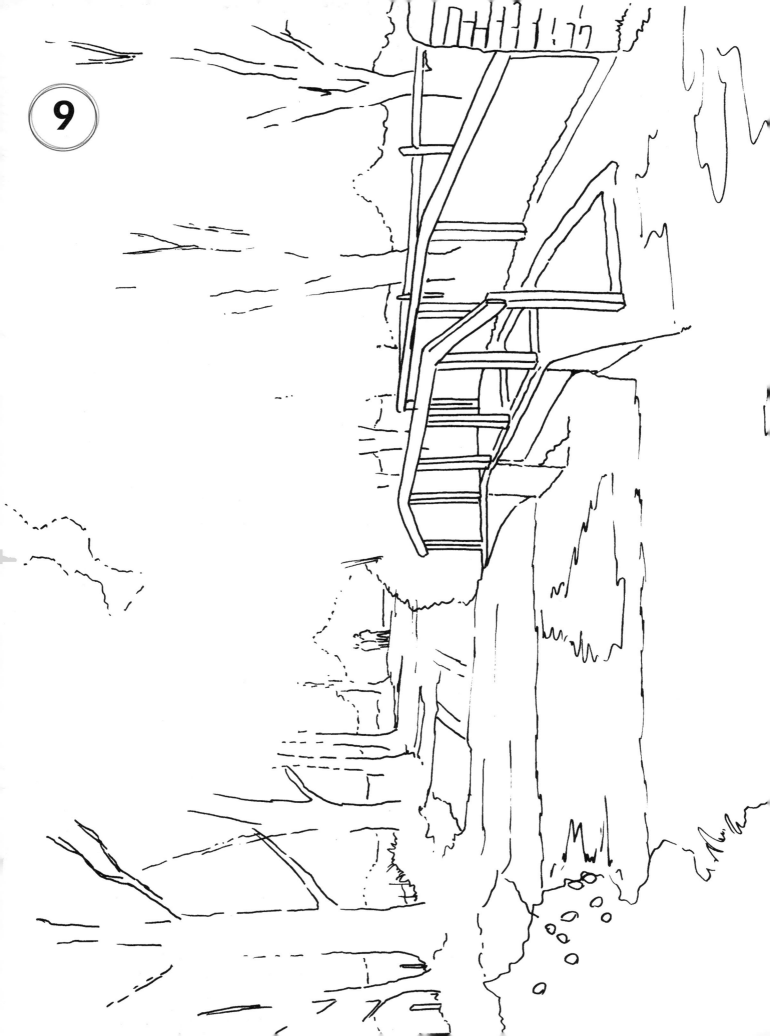

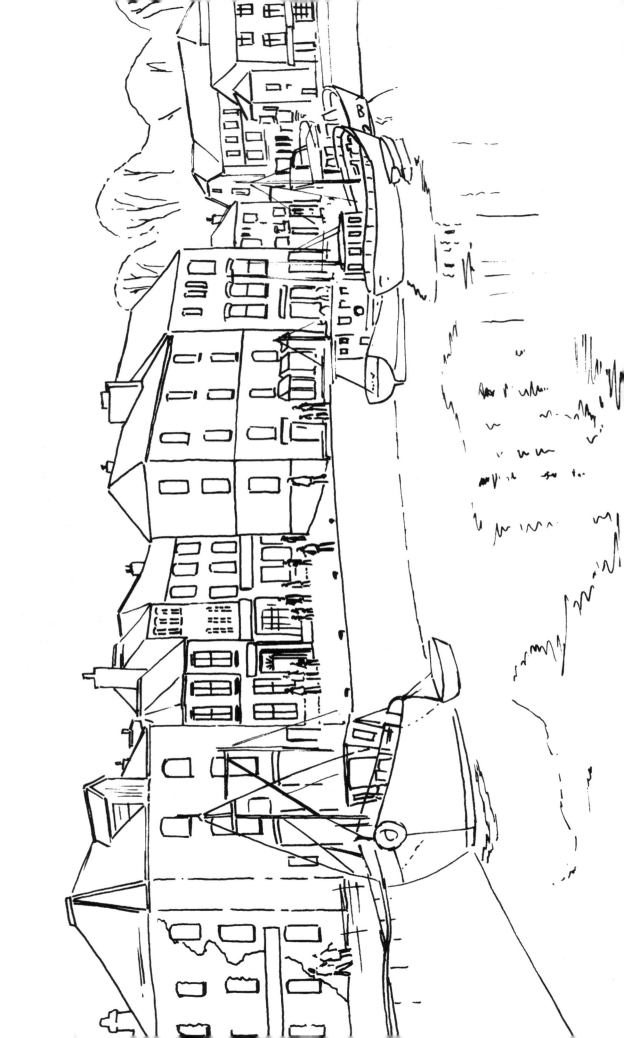

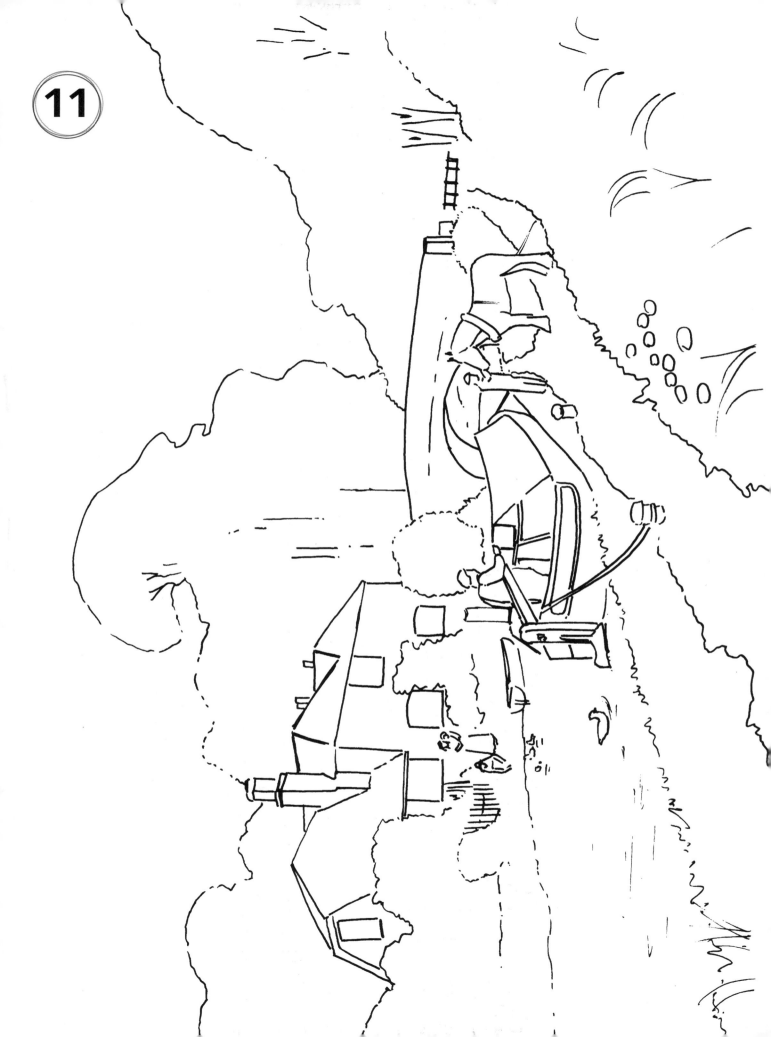

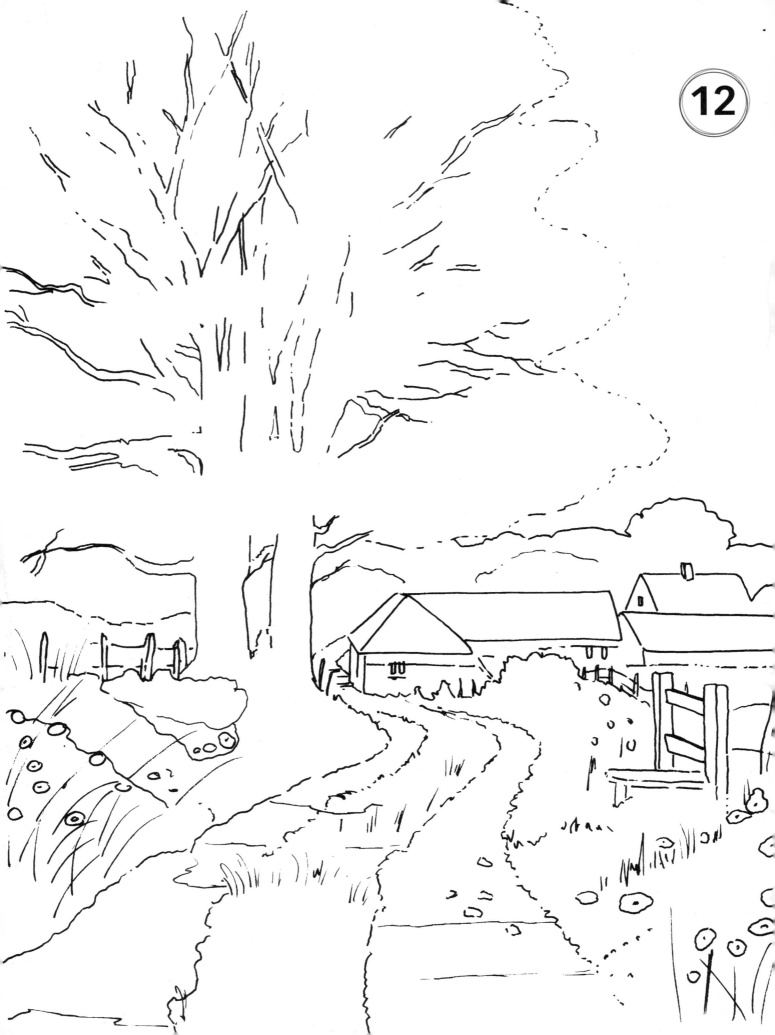

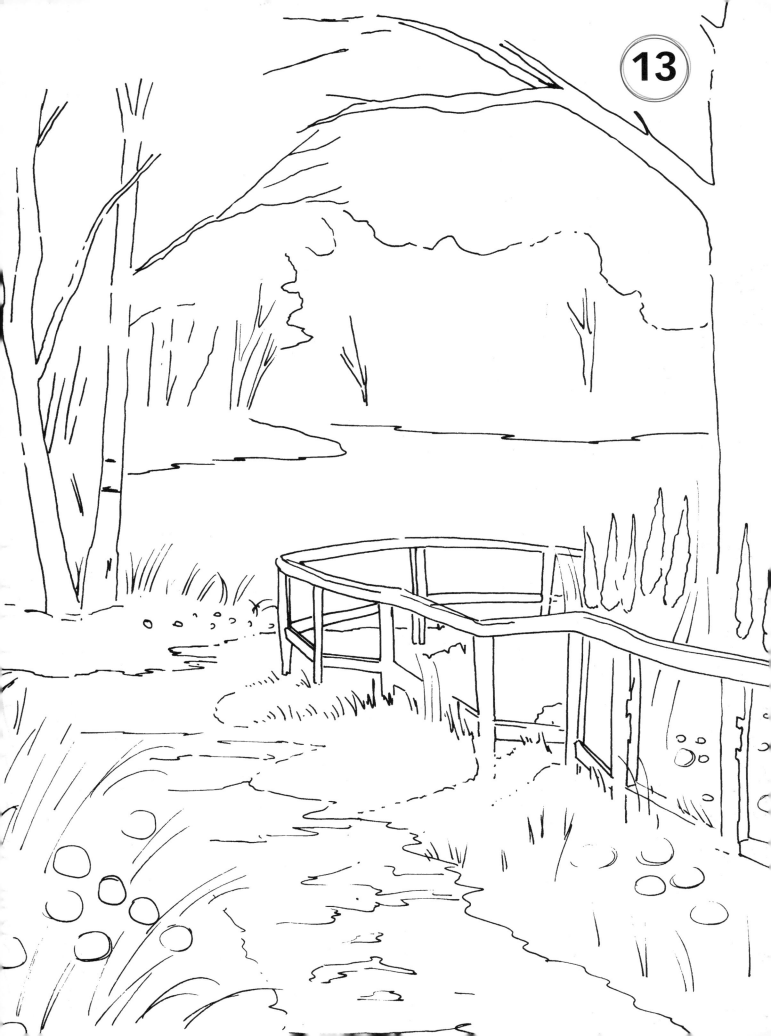

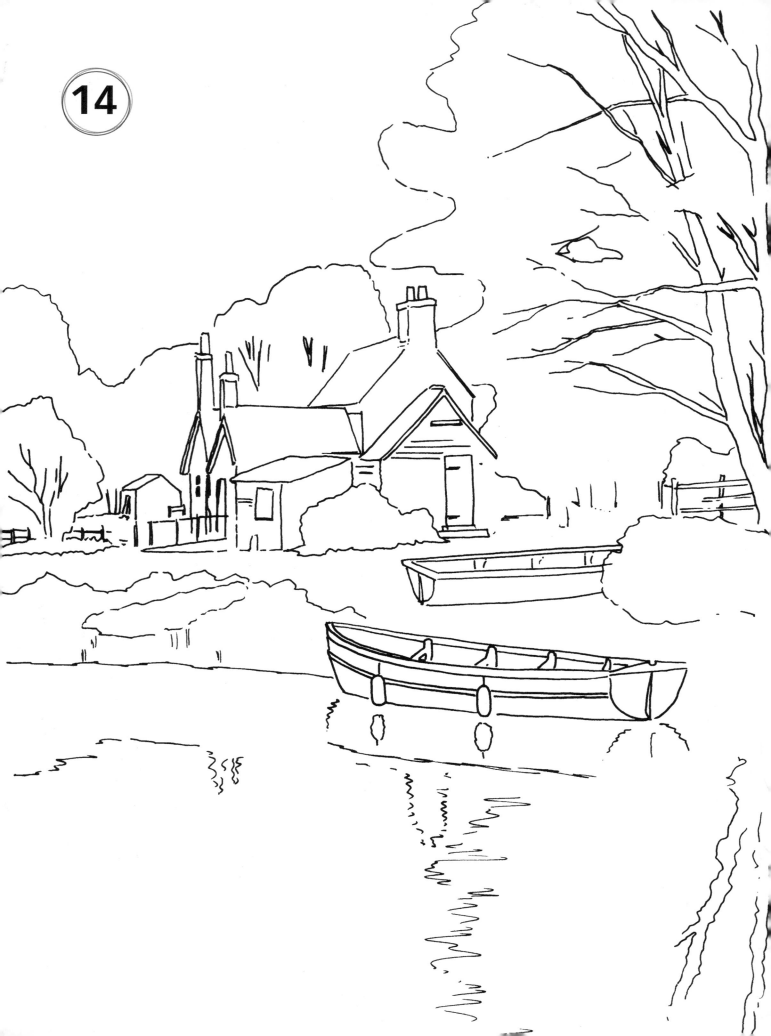

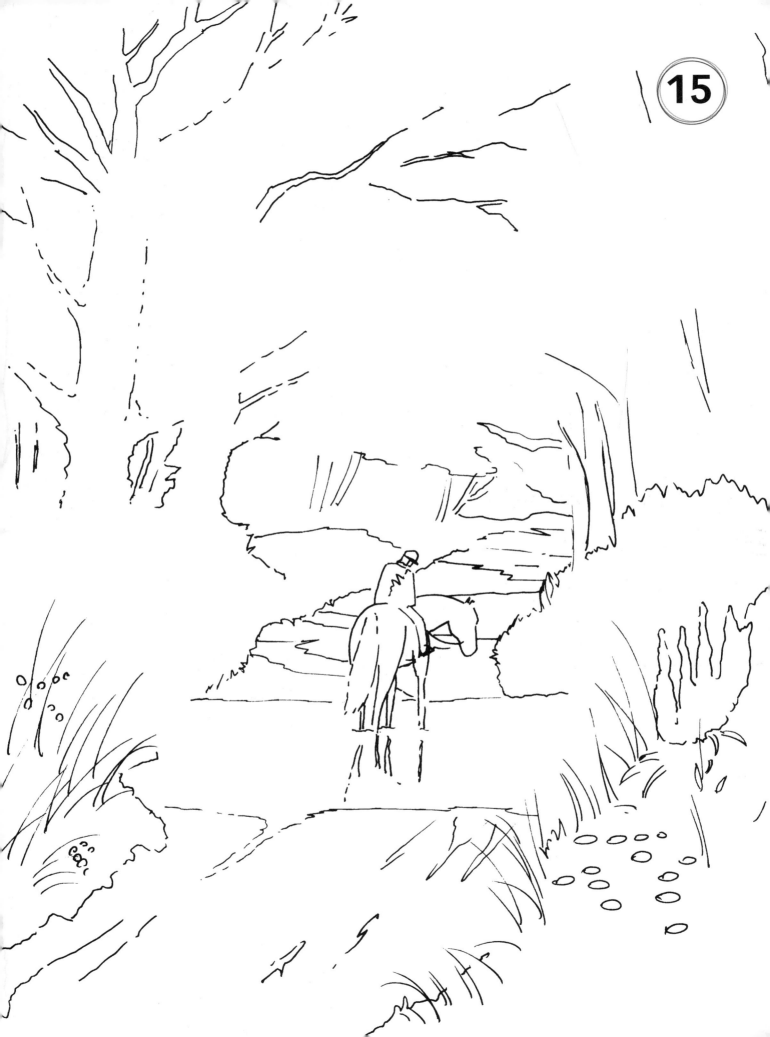

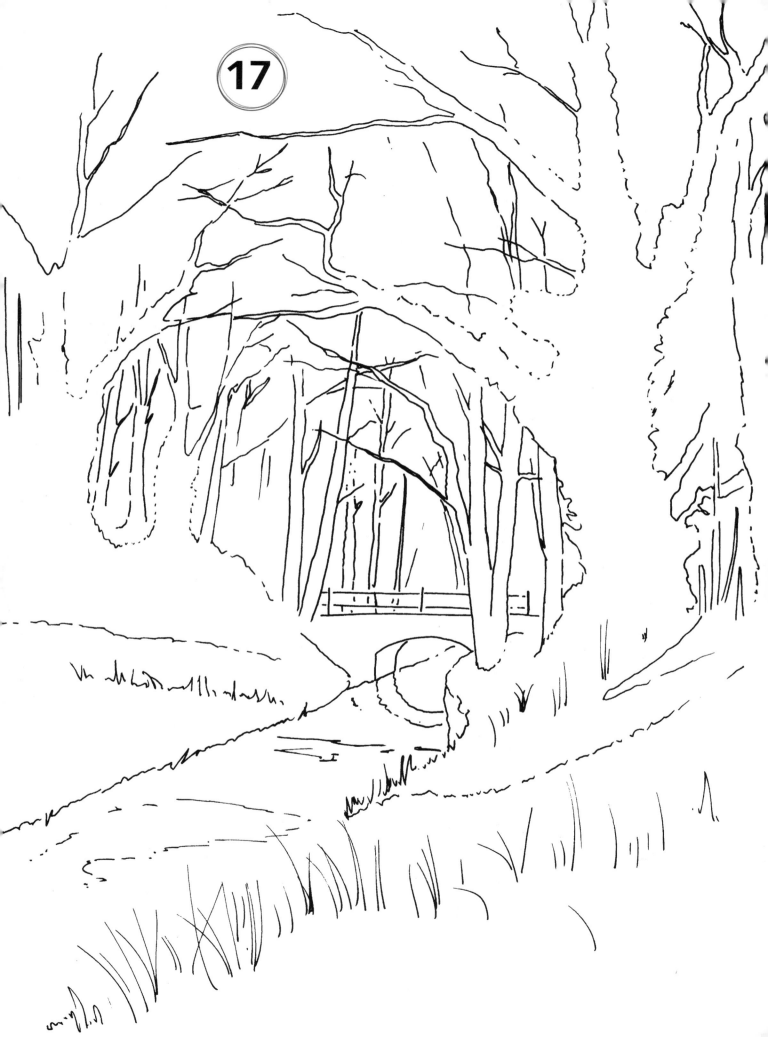

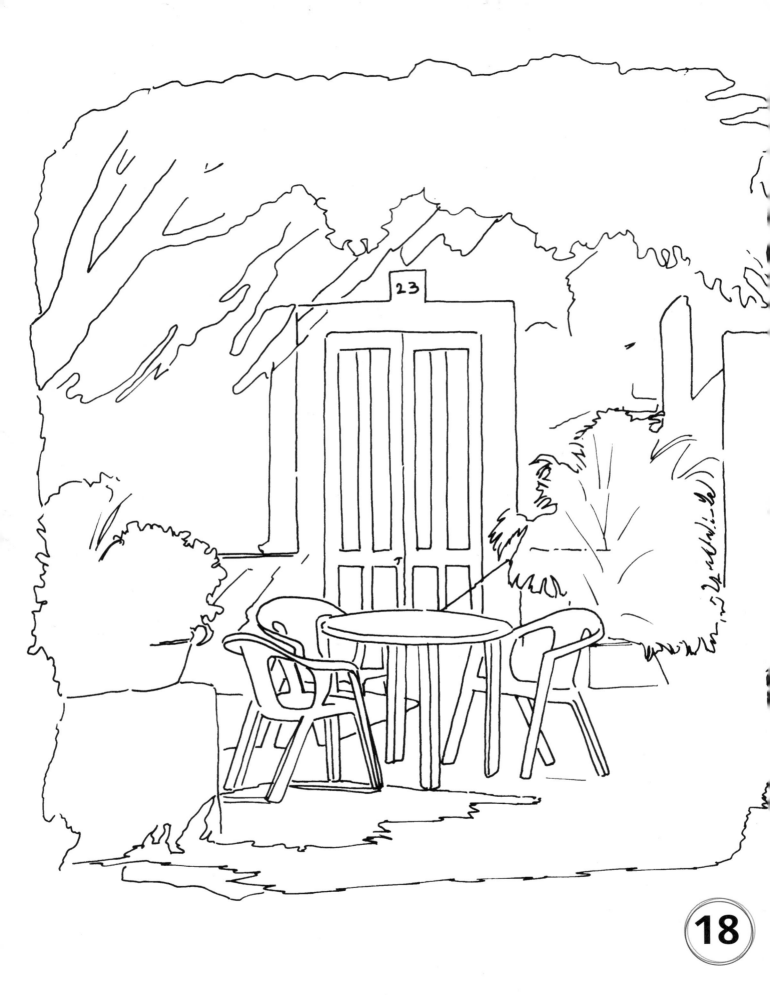

23

18

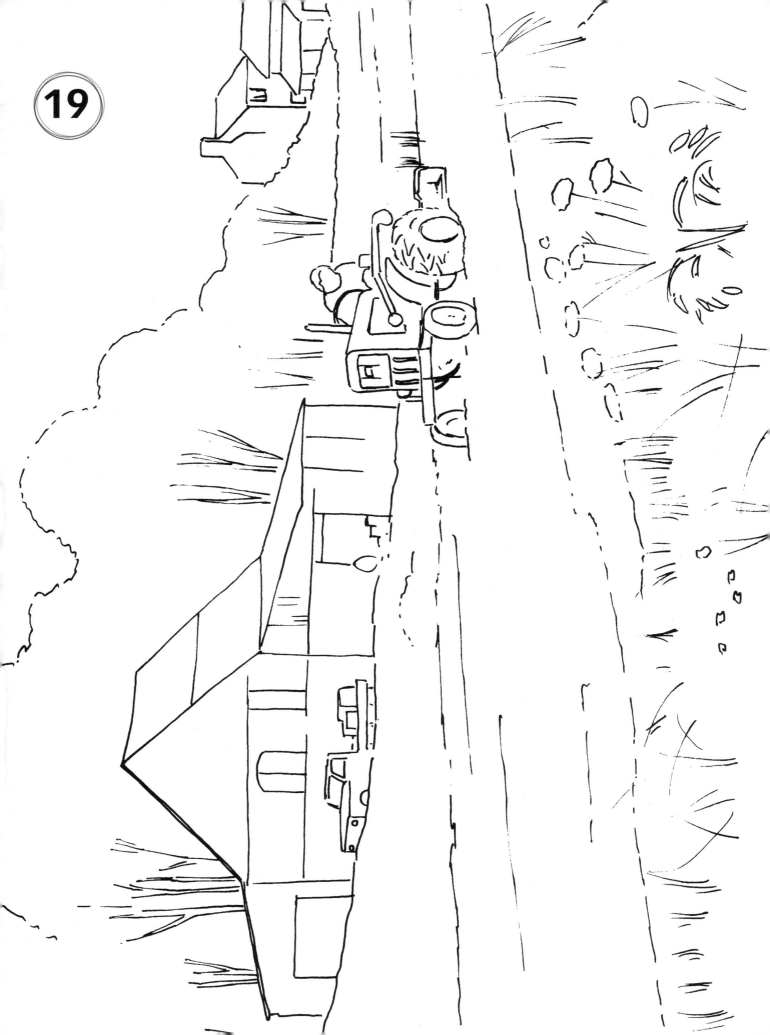

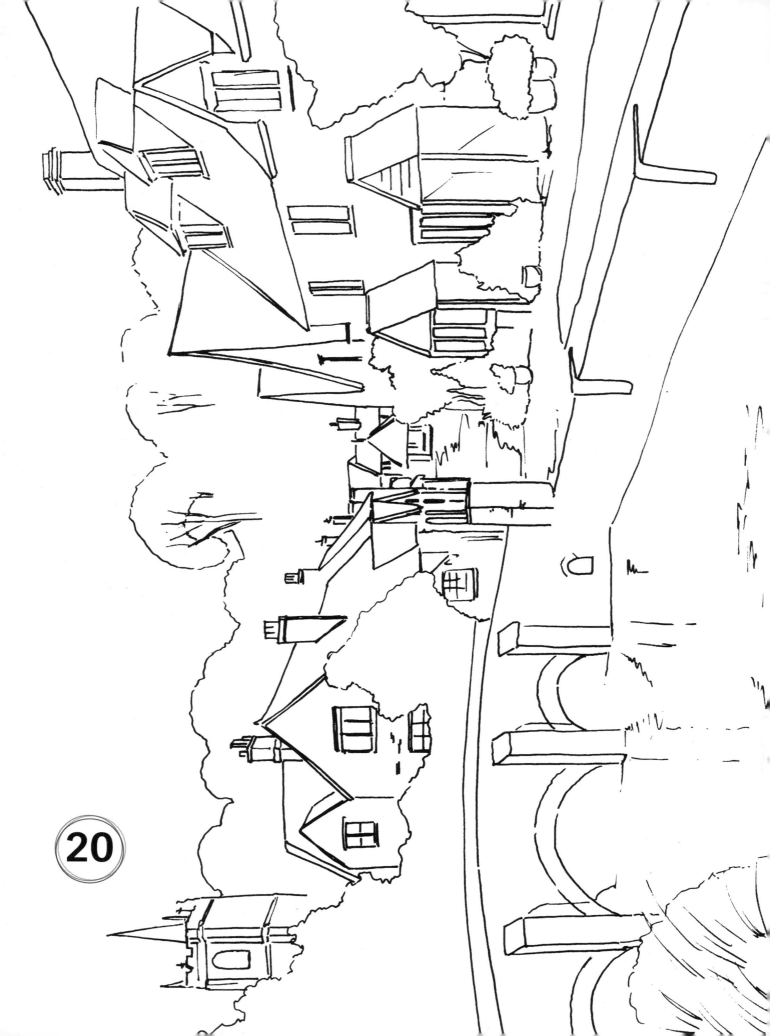

20

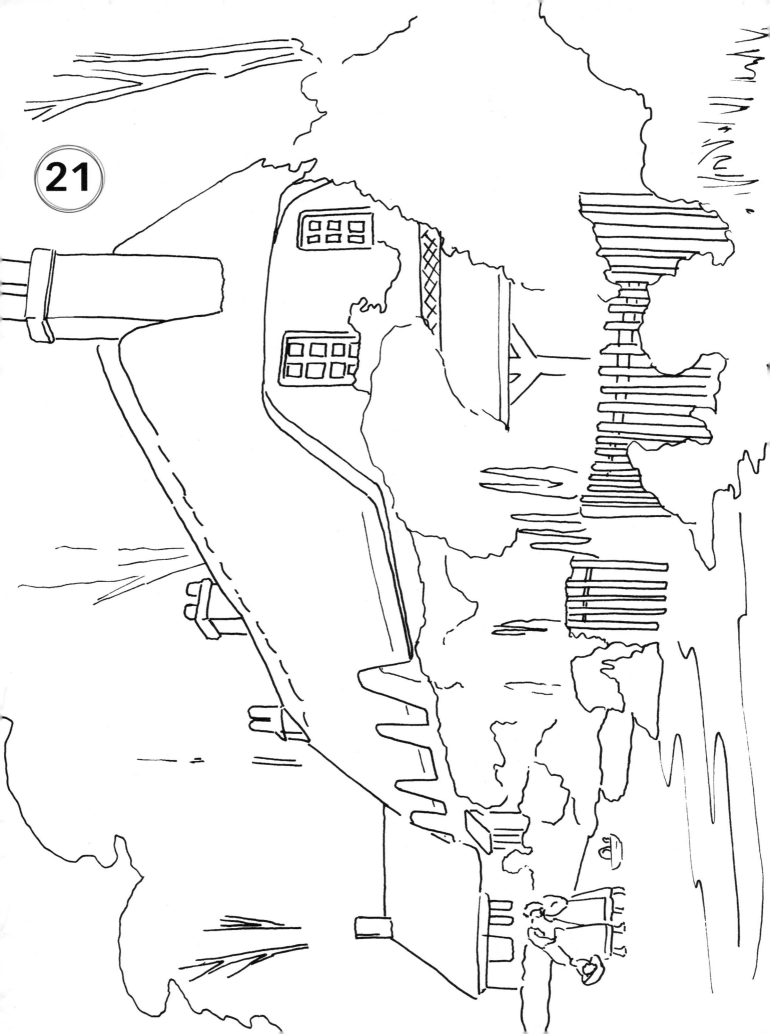

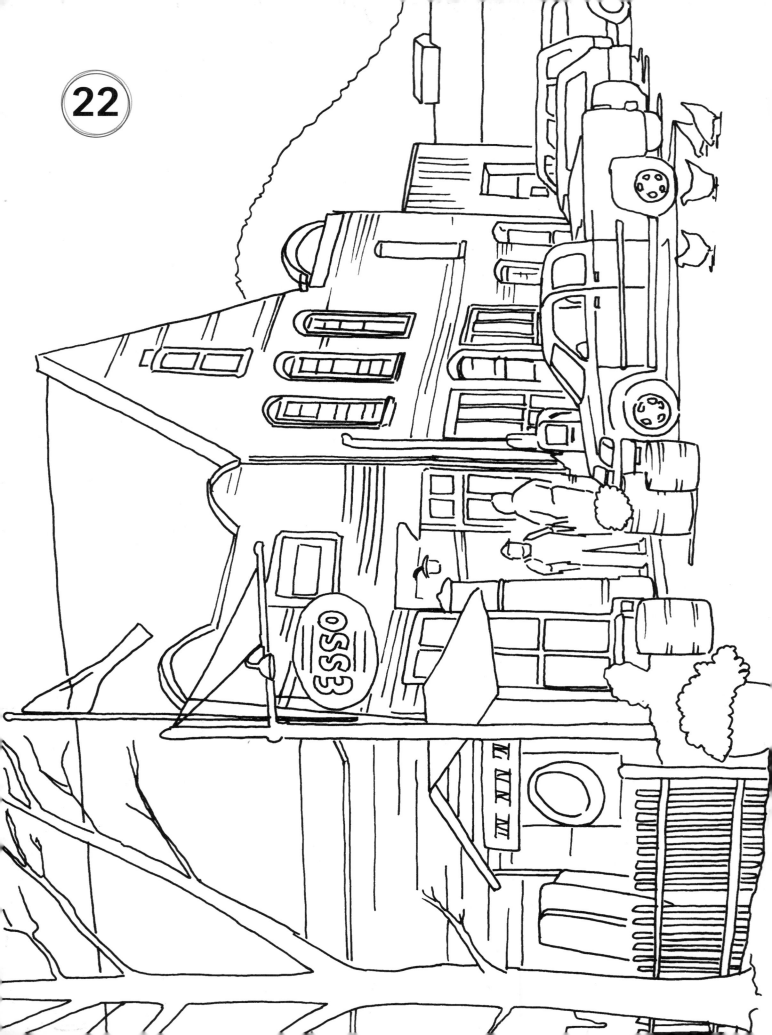

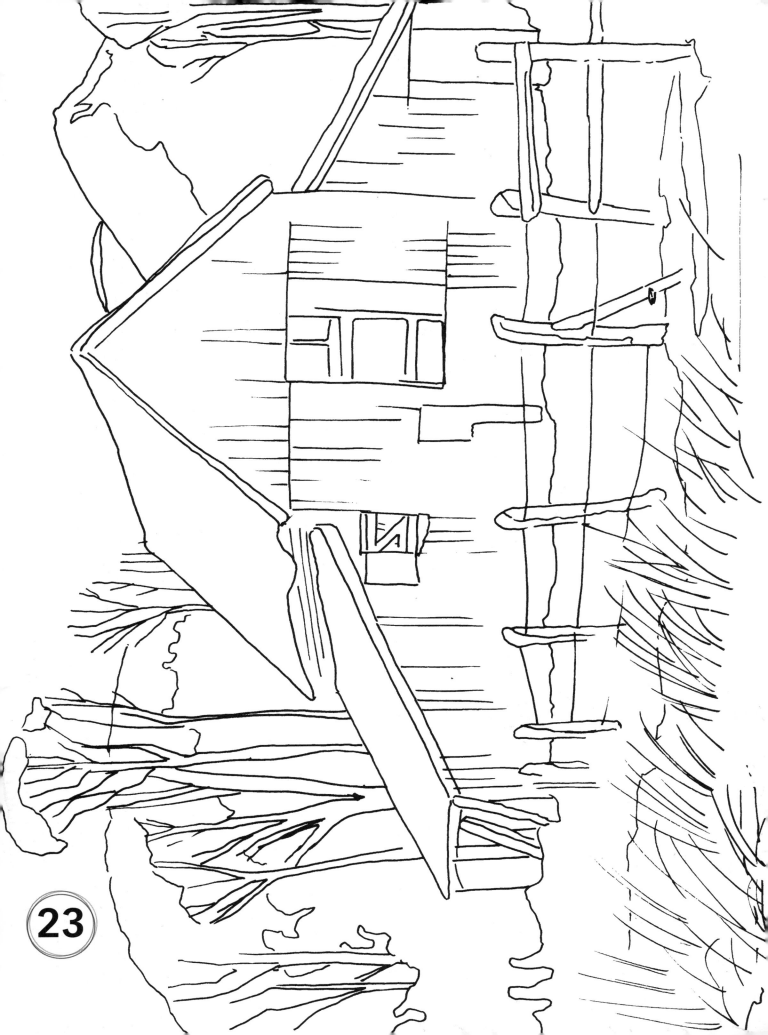

23

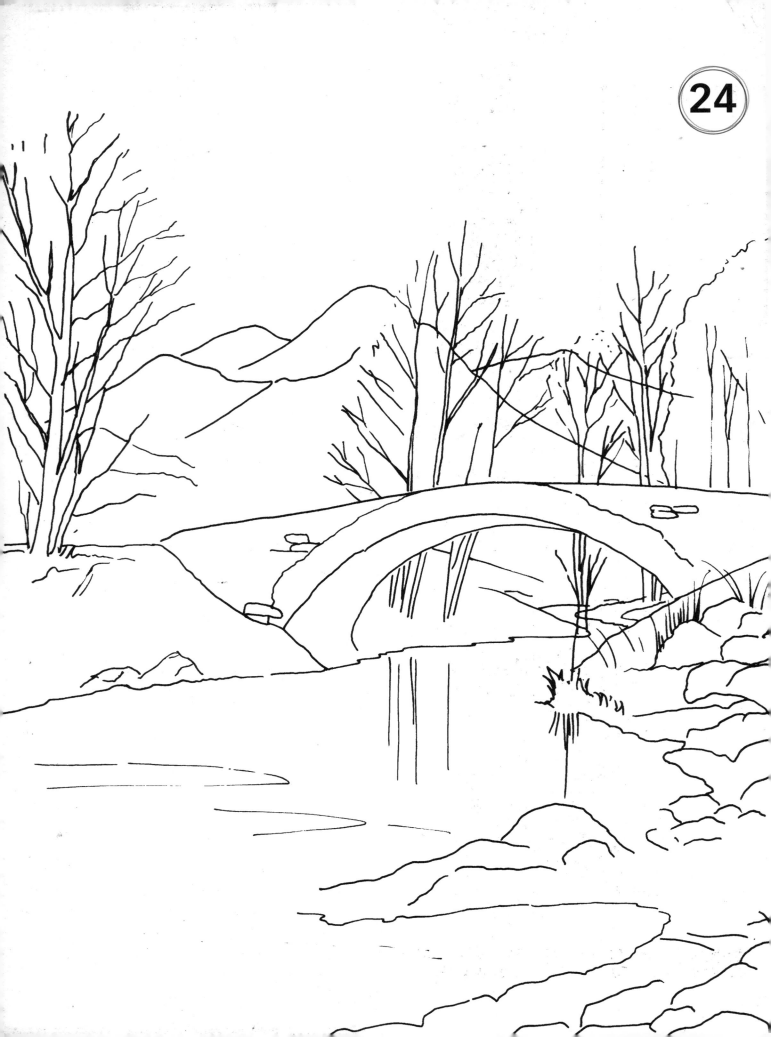